HISTORIC
AIRCRAFT
WRECKS

— OF —

SAN DIEGO
COUNTY

HISTORIC
AIRCRAFT
WRECKS

— OF —
SAN DIEGO
COUNTY

G. PAT MACHA

THE
History
PRESS

Published by The History Press
Charleston, SC
www.historypress.net

First published 2016

Manufactured in the United States

ISBN 978.1.46711.836.1

Library of Congress Control Number: 2016934223

To those who lost their lives while in military service on behalf of our nation, and to honor those who were aerial first responders lost on search and rescue, firefighting and law enforcement missions in San Diego County, California.

CONTENTS

FOREWORD

The year was 2003. I had just finished reading a local news story about Pat Macha and his search for missing aircraft in the waters of Santa Monica Bay, California. I was intrigued. At that particular time, I was involved in a search of my own. Not for a missing aircraft but for the remains of ex-German submarine *UB88* that was scuttled off Long Beach in 1921.

I didn't know it at the time, but Pat and I were practically neighbors. We lived two miles apart in the city of Huntington Beach. We soon met to discuss a new sonar technology that would eventually lead us to discover several historic aircraft wrecks off Southern California.

One such discovery was a missing Lockheed T-33 T-Bird that disappeared after takeoff from Los Angeles International Airport in 1958. One of our most significant collaborations is a story you'll read about in the pages of this book: the discovery and identification of a Convair B-36 Peacemaker that crashed off Mission Beach in 1952.

These discoveries represent just a small fraction of the cases Pat Macha has researched and explored throughout the state of California since discovering his first mountain crash site in 1963. His desire to learn the details of that first accident fueled an avocation that has lasted more than half a century.

For the past twenty-five years, Pat has dedicated himself to helping next of kin find answers about their loved ones lost in aircraft accidents. Along with his Project Remembrance Team, Pat has assisted more than one hundred next of kin fulfill their wish for accident reports, maps, photographs and crash site visitations.

Through his books, website and public speaking engagements, Pat continues to make lasting contributions to aircraft archaeology and California's rich aviation history.

I'm honored and privileged to call Pat a friend.

Gary Fabian
Founder, The UB88 Project
Huntington Beach, California

ACKNOWLEDGEMENTS

This book would not have been possible without the help and encouragement of many individuals and organizations. Thanks go to the following:

Fred Beam, Civil Aeronautics Board accident investigator; aviation historian David D. Hatfield; Robert "Bob" Koch (RIP), USAF retired; Captain Paul Stebelton, USAF and FAA (retired); Bob Bhrule, Civil Air Patrol; Joel Bishop; and Elgin F. "Butch" Gates (RIP), whose newspaper research provided much help regarding aircraft accident stories and histories. David Mihalik and Thomas Maloney for hundreds of hours of newspaper research that was key to both story content and to locating crash sites in San Diego County. Project Remembrance Team members Chris LeFave; Ryan Gilmore; Thomas Maloney; David Mihalik; Dennis Richardson; David Lane; Bruce Guberman; Jana Churchwell; Tony Accurso and his daughter, Evelyn; Walt Witherspoon; Dan and Leslie Catalano; Dave Trojan; and James "Jamie" Lievers. Joel Bishop, California Highway Patrol, retired; Captain Alan Dow, Civil Air Patrol; Trey Brandt; Marc McDonald; Brad Eells; Lewis Shorb; and Jeff Corder, an inspiration regarding next of kin issues. Fellow authors Eric Blehm, Milo Peltzer and Nicholas A. Veronico, who encouraged me to pursue my goal of writing this book. Craig Fuller, founder of Aviation Archaeological Investigation & Research (AAIR), provider of countless accident reports and photos. George Petterson, National Transportation Safety Board investigator (retired), master pilot and aviation safety educator,

whose insights and help have been indispensable in understanding the many factors involved in aircraft accidents. Special thanks to William T. Larkins, author and founder of the American Aviation Historical Society (AAHS), who supplied historic photos used in this edition, and to AAHS president Jeri Bergen. Lee Anderson of VP48.Org, Gary Fabian and his UB88.Org team, whose members include Captain Kyaa Day Heller, Kendall Raine, John Walker and Captain Ray Arntz, all of whom played a key role during the search effort for the B-36 and other aircraft wrecks off the San Diego coastline. Special thanks to noted scuba divers Steve Lawson and David Finnern for their assistance with several stories. Gratitude for assistance with photo acquisition to Cynthia Macha, director of the Western Museum of Flight. Thanks to Debbie Serecini, assistant archivist at the San Diego Air & Space Museum, and Megan Laddusaw, commissioning editor for The History Press, for her help and encouragement in completing this book project. Special thanks to Ron Funk, webmaster for www.aircraftwrecks.com, for scanning and resizing all images used in this book.

Special thanks to San Diego County residents Dennis Richardson, James "Jamie" Lievers, Betty McMillen, Billy Ortiz, David Lane, Kurt Bidinger, Scott Borg, Mike Clauser, Deena Nelson, John P. Jensen Sr., Chuck Palmore and Scott Dedenham. Thanks also to Kurt Dalton; Don Endicott; Ernie Cowan; Desiderio "Desi" Vela; environmental program manager Ewiiaapaayp Band of Kumeyaay; Jim Robertson, Ewiiaapaayp Band tribal representative; Larry Thompson, Manzanita Band of Kumeyaay; P.J. Banks, Los Coyotes Band of the Cahuilla and Cupeno; Barona Band of Mission Indians tribal elder Boxie Phoenix; and Jacqueline Whaley. Special thanks also to Mr. Lee Anderson and www.VP-48.org.

I thank my family for encouraging and supporting my avocation and for joining me in fifty-one years of hiking and searching, sometimes risking life and limb in the process. I salute my parents, Charles F. and Mary Francis Macha (RIP). My father served in the Thirteenth Airborne Division, Eighty-eighth Glider Infantry Regiment, during World War II, and his aerospace career with Douglas, Lockheed and North American Aviation/Rockwell/Boeing spanned forty years. From him I learned about aircraft structure and prefix numbers, not to mention a love of everything aerospace history related. My younger brother, Chris, and my sister, Cindy, started hiking with me in the 1960s. Mary Jane, my wife of forty-eight years, has been on the trail with me since we started dating

in 1966. Our son, Patric Joseph, and daughter, Heather Maureen, along with their respective families, have all participated in visiting crash sites in San Diego County and beyond. Finally, I acknowledge my editor and wife, Mary Jane Macha, without whose tireless help this book would not have been completed.

INTRODUCTION

The year 2016 marks my fifty-third year of searching for and documenting aircraft crash sites on open space areas throughout the state of California. I came to this unique avocation while working at a youth camp in the San Bernardino Mountains of Southern California in the summer of 1963. My camp job was hike master, and that included nature walks, day hikes and overnight camping trips into the San Gorgonio Wilderness. A highlight of the overnight trips included the ascent of Mount San Gorgonio, the highest peak in Southern California, at 11,503 feet. The prescribed route to the summit was via the Poop Out Hill Trail Head to a bivouac site at Dollar Lake. After a night's rest, we hiked to the summit of Old Greyback, where the view on a good day could be one hundred miles or more. Following lunch at the top, we reversed our course, picking up our packs and gear at Dollar Lake to begin the trek back to the parking lot at Poop Out Hill, where a stake bed truck would return us to YMCA Camp Conrad in Barton Flats. We averaged eighteen and a half miles in two days on these wilderness treks. Continuous route repetition led me to try another way down from the summit where no trail existed in those years. On our first descent on the east flank of Greyback, we stumbled on the crash site of an air force transport plane that I recognized to be a Douglas C-47. Our group was dumbstruck as we surveyed a scene of devastation where wings, landing gears and engines were interspersed with personal effects, uniforms, shoes, luggage bags and headphone sets. Campers and counselors asked me what happened, and when, and who was on board. I wanted to know the answers

to these questions myself. The aluminum structure looked new, bright and shiny. Our stars and bars national insignia was visible on one of the wings, and "USAF" was painted on the other. I photographed the crash site that day with a Argus C3 35mm camera borrowed from my father, from whom my love of everything airplane comes. I did eventually learn the story of the C-47 tragedy from a US Forest Service ranger at Barton Flats Station. He also shared with me the locations and stories of eight other aircraft crash sites that he had seen during his long tenure in the San Bernardino Mountains. This ranger opened a door to the past, and I began the long search that has continued to this day looking for crash sites that are scattered across the mountains, hills and deserts of California. Unlike roadside vehicle accidents that are quickly cleaned up and forgotten, aircraft wreck sites in remote locations remain largely undisturbed in deep canyons, hidden in forests, overgrown in the chaparral or widely scattered in small parts across vacant desert landscapes where few people venture.

San Diego County is the ninth largest county in California, covering 4,526 square miles. The population continues to grow, reaching an estimated 3.3 million in late 2015. Three major highways serve the county: Interstates 5, 8 and 15. Federal and state agencies are the majority landowners, with seventeen state parks, the Cleveland National Forest, the BLM and sixteen military installations. San Diego County is also home to eighteen tribal reservations. The topography is diverse, including coastal plains, lagoons, bays and numerous valleys, with twenty-seven named hills and mountain ranges. The highest point in the county is 6,512-foot Hot Springs Mountain located in the Laguna Range. Other notable ranges include the Volcan, Palomar, Santa Rosa, Vallecito, In-Ko-Pah, Jacumba, Santa Margarita and Otay Mountains. The rugged Anza Borrego Desert includes Clark Dry Lake and Ghost Mountain. Major rivers are the Santa Margarita, San Luis Rey, San Dieguito, San Diego and Sweetwater. Major lakes and reservoirs are the Cuyamaca, Barrett, El Capitan, Henshaw, Hodges, Lower Otay and Wohlford. San Diego County is bordered on the west by the Pacific Ocean, on the north by Orange and Riverside Counties, on the east by Imperial County and on the south by the United Mexican States.

Into this varied topography and the Pacific Ocean lie more than four hundred aircraft crash sites, including many dozens presumed lost at sea. This book will give the reader a glimpse into aviation accident stories, histories and mysteries that remain today on private, public and open space lands and beneath the Pacific Ocean.

From the very beginning of manned flight in the United States, the climate and open spaces of San Diego County have offered early aviators, both civilian and military, a near perfect place in which to fly, train, manufacture and test aircraft. Aviation pioneer John J. Montgomery is reported to have flown gliders on Otay Mesa from 1884 to 1886. The second decade of the twentieth century saw the establishment of military and civilian flight schools at North Island. Such aviation notables as naval aviator Lieutenant Theodore Ellyson and famed pioneer Glenn Curtiss were flying there in 1911 and 1912, respectively. The US Army Signal Corps and its successors, the Army Air Service and Army Air Corps, operated from Rockwell Field on North Island until 1937. By the mid-1920s, San Diego County had become the domain of navy, marine corps and coast guard aviation. Along with the military airfields came aircraft manufacturers, beginning in 1922 with Claude T. Ryan, founder of Ryan Aeronautical Company. In 1935, Ruben H. Fleet moved his Consolidated Aircraft Company to San Diego, where he began building the famous PBY Catalina flying boat series, followed by the B-24 Liberator series of heavy bomber aircraft. Another aviation pioneer, F.H. "Pappy" Rohr, established the Rohr Aircraft Corporation. The Second World War (1941–45) witnessed a rapid expansion of military bases and flight training fields. The postwar aviation boom continued as the Consolidated and Vultee merger led to the creation of Convair. Convair became a prolific source of military and commercial aircraft, missiles and rockets until operations in the county ceased in 1996.

At the zenith of aviation activity in San Diego County, there were more than thirty military and civilian air bases, airports and landing strips. By 2015, the number of military air bases and airfields had shrunk to four, while fourteen civilian airports continue to operate, including historic Lindbergh Field, home to San Diego International Airport. Nevertheless, twenty military and civilian airports and airstrips have closed in the past half century.

San Diego County continues to enjoy an important place in aerospace past, present and future. North Island Air Station, formerly known as Naval Air Station San Diego, has been in continuous operation since its founding in 1917. In 2015, NAS North Island was home to sixteen navy helicopter squadrons and two transport squadrons serving the needs of the Pacific Fleet. The aerospace industry in San Diego, led by Northrop Grumman and General Atomics, employs more than thirty-five thousand people, and this number continues to grow, as do the markets for unmanned aircraft and space-based technologies.

CHAPTER 1

FLYING INTO THE STORM

The nineteenth century got off to a flying start in San Diego County at first with balloons, gliders and, later in the early twentieth century, powered aircraft. John J. Montgomery is credited with the first manned glider flight from Otay Mesa on August 28, 1883. Professor Montgomery went on to make more than fifty glider flights; however, he was killed in Santa Clara County, California, on October 31, 1911, in a flying accident. Montgomery Field in San Diego County is named for this early aviation pioneer, as is Montgomery-Waller Park on Otay Mesa, where State Historical Landmark number 711 is located. This landmark honors the memory of Professor John Joseph Montgomery and his contributions to manned flight.

The year 1911 witnessed the arrival of powered aircraft in San Diego County. North Island became the site of the Glenn Curtiss School of Flight. A notable graduate of the Curtiss School was US Navy lieutenant Theodore G. Ellyson, who became Naval Aviator No. 1. Lieutenant Ellyson survived a minor flying accident at North Island and went on to fly the first Curtiss seaplane, called the A-1. Lieutenant Ellyson's distinguished career came to a tragic end in 1928 when he was killed while flying a floatplane over Chesapeake Bay.

Thanks to the piloting and engineering acumen of Glenn Curtiss, both the US Navy and the army signal corps began purchasing Curtiss training aircraft that helped pave the way for military aviation in America. The army signal corps began flight training in 1912 at Coronado, and famed army aviator Jimmy Doolittle earned his wings there. In 1918, the facility was

renamed Rockwell Field, and in 1922, the army moved all flight training to Kelly Field, Texas. In 1918, North Island Naval Air Station was established, and it has been in continuous operation ever since, absorbing adjacent Rockwell Field in 1939.

As training activities accelerated following the United States' entry into World War I, so did the rate of aircraft accidents. The causes and factors in these early losses included mechanical, stall/spin, midair collisions, weather and pilot error. From 1912 to 1940, more than 85 army aircraft were heavily damaged or completely destroyed. Navy and marine losses for the same period totaled more than 250 aircraft heavily damaged, destroyed or missing. Midair collisions alone accounted for the loss of more than 35 aircraft and forty lives.

San Diego County is well known for its good weather. Winter storms are few, summer thunderstorms are occasional and coastal stratus clouds and fog, while not uncommon, usually burn off by late morning.

One common sight in the 1920s over San Diego County was the DeHavilland DH-4, flown by the army air service, marine corps and navy. The DH-4B and other Liberty plane variants served in bombing, observation and training roles until the type was finally retired in 1932. The DH-4 was designed and built in England to serve in WWI as a light bomber, but early production aircraft earned the nickname "Flaming Coffins" in combat operations because of the fuel tank location and the pilot's seating arrangement. Once the modified DH-4B appeared, combat effectiveness and crew safety were substantially improved. During the war, licensed production was undertaken in the United States by Dayton-Wright Company, Fisher Body Division of General Motors and Standard Aircraft Company. Together these companies built 4,846 "Liberty planes," as the DH-4B came to be called in the United States. The DH-4B power plant was designed in the United States by a consortium of automobile engine manufacturers. Engine production was led by Buick, Cadillac, Ford and Lincoln. More than 20,000 of the V-12 four-hundred-horsepower Liberty engines were produced between 1917 and 1919.

One early military aircraft accident that occurred in a remote area of San Diego County happened during the flight of US Army Air Service DeHavilland DH-4B serial number AS63780, which disappeared on December 7, 1922, with two army officers on board. The pilot was First Lieutenant Charles F. Webber, age twenty-six, and his passenger, Colonel Francis C. Marshall, army deputy chief of cavalry, was fifty-five. This should have been a routine flight from Rockwell Field to Fort Yuma, Arizona, for

a refueling stop and then continuing to Tucson, Arizona, where Colonel Marshall was to conduct an inspection of an ROTC cavalry unit. The flight was to continue that same day to Fort Huachuca for the inspection of the Tenth Cavalry.

Lieutenant Webber had a number of variables to consider in planning his five-hundred-plus-mile flight into Arizona. At the top of the list were his route, fuel supply, aircraft gross weight, cruising speed, cruising altitude and the all-important weather report. Lieutenant Webber knew that his flight was already complicated by a rapidly approaching early winter storm front. In 1922, aviation weather reports were rudimentary at best, relying on telephone or Western Union messages from stations along the track of approaching storms. At Rockwell Field, the weather data available to flight crews included air temperature, wind speed and direction, visibility and barometric pressure. There were no weather alerts concerning cloud buildups, high wind warnings or reports of severe turbulence available to aviators.

Lieutenant Webber was an experienced aviator with more than six hundred flight hours to his credit, but he was handicapped by the lack of cockpit instruments and radios that are commonplace in aircraft today. AS63780 was equipped with a compass, altimeter, airspeed indicator, engine temperature and fuel gauges. Lieutenant Webber's flight plan was thought to have followed State Highway 94 (Old Highway 80, now

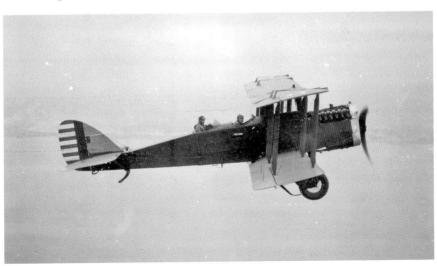

US Army Air Service DeHavilland DH-4B, similar to one that crashed on December 7, 1922. *San Diego Air & Space Museum.*

Interstate 8), which paralleled the Mexican border. This was considered the safest way to cross the mountains east of Rockwell Field, but storm clouds were already arriving over the mountains when the ill-fated DH-4B departed at 10:00 a.m.

When Lieutenant Webber failed to report on December 8, 1922, Major Henry H. "Hap" Arnold sent telegrams to all airfields along the flight route to determine if AS63780 had landed at any of them. When all responses were posted as negative, Major Arnold ordered search and rescue efforts to begin immediately. Sheriff's departments in Southern California and Arizona were alerted about the missing army air service DH-4B, as were the forestry service and Mexican government.

Army chief of staff General John J. "Black Jack" Pershing ordered air units from March Field in California and Fort Bliss in Texas to join in the search efforts. While search missions were conducted into Arizona, it was widely speculated that the missing DH-4B had gone down in the mountains of San Diego County or northern Mexico. Naval aircraft from North Island joined the aerial search efforts, as did aircraft flown by the Forest Service. Civilian volunteers joined in too. As the days passed, reports of sightings of the missing aircraft increased across Southern California, Arizona and even New Mexico. Alvaro Obregon, the president of Mexico, authorized US military aircraft to fly search missions over northern Mexico and mobilized ground searches by his federal police.

By December 18, the air aspect of the search effort was ordered suspended, but ground efforts continued until winter snowfall blanketed the Laguna Mountains, forcing remaining volunteers to focus their efforts on lower elevations and the vast desert areas of the Southwest. The largest peacetime search effort in American history was winding down, but at its height more than forty aircraft and almost one thousand military and civilians had participated. The grief-stricken family of Colonel Marshall and officer friends of Lieutenant Webber offered a $700 reward for information leading to the discovery of the Liberty plane.

Even as search efforts were curtailed, more attention was paid to witness statements, including that of Major Arnold, who had followed Lieutenant Webber's departure from Rockwell Field on December 7 in a fighter biplane, only turning back as the DH-4B flew into a cloudbank over the foothills of the eastern San Diego County mountains. Other eyewitnesses reported seeing or hearing an aircraft on December 7 flying near Descanso, Viejas, Guatay, Green Valley and the Cuyamaca Mountain area. Intermittent

military search flights and the deployment of ground troops continued into 1923 without success.

As is often the case regarding the fate of a long-missing aircraft, the discoverers are usually hiking, climbing or riding in an area off the beaten path when they stumble upon what has been so long sought after. That was the case with San Diego County rancher George W. McCain, who was horseback riding with a friend along Japacha Ridge in the Cuyamaca Mountains on Saturday morning, May 12, 1923. McCain looked down into the Japacha Creek drainage and saw the mangled remains of the missing DH-4B. The large, relatively intact Liberty engine was the most prominent piece of wreckage. It was immediately apparent that a post-impact fire had consumed much of the airplane, but sections of outer wing, with the army roundel insignia, were still recognizable with flag blue and flag red paint. The wire wheel assemblies were still intact, but the rubber tires were not.

As McCain surveyed the crash site, he saw two piles of burned bones: the remains of Lieutenant Charles F. Webber and Colonel Francis C. Marshall. He also noted that the tops of two pine trees on the ridge above the crash site were sheared off. Before departing to notify the authorities, McCain collected a piece of burnt canvas as evidence of his discovery. He then rode to Lake Cuyamaca, where the nearest telephone was located, and relayed his message of discovery to the county sheriff and Major Arnold at Rockwell Field.

Word of the DH-4B wreck somehow reached local newspaper reporters, who attempted to find the crash site; however, darkness and dense fog thwarted their efforts. When McCain returned to the crash site, he was accompanied by fog-bound reporters and many local residents. McCain instructed all present not to touch anything until the army team arrived to investigate.

When Major Arnold arrived with three officers and six enlisted men to conduct a crash site investigation, he found he had plenty of civilian volunteer company. The first order of business was to secure the accident scene and recover the personal effects of the victims. After photographing the site, Major Arnold and his team, accompanied by civilian volunteers, scoured the ridgeline, where they located parts from the DH-4B that had been knocked off as the aircraft hit treetops prior to its death plunge.

The crash site was evacuated on Sunday, May 13, 1923, with the remains and personal effects of Lieutenant Webber and Colonel Marshall. Major Arnold determined that no useable material could be salvaged from the DH-4B and the wreckage would not be recovered.

What had happened to the ill-fated DH-4B would be described in the official army accident report that was published on December 22, 1923. The findings were as follows: citing weather conditions along the flight route, the pilot's vision was diminished by clouds and fog, and the aircraft struck trees on the ridgeline and crashed. The deaths of the pilot and passenger appear to have been instantaneous. Finally, "it was an unavoidable accident, for which no one can be held accountable." Major Arnold thought the DH-4B would have been found quickly had snow not fallen in the Cuyamaca Mountains on the night the plane disappeared.

Lieutenant Webber had not flown into a storm per se, but he had flown into weather conditions where visual flight rules do not apply. Lieutenant Webber was not instrument rated because the pioneers of instrument flight were not yet on the scene in 1922. Had Lieutenant Webber lived to fly a decade later, he would have had the opportunity to pilot an aircraft with the Sperry Gyroscope, an improved altimeter and a visual radio direction finder. Using these aforementioned technologies, Jimmy Doolittle was awarded the Harmon Trophy when he accomplished the first completely blind flight in 1929.

In most aviation accidents, there are a number of factors to be considered. In the case of US Army Air Service DeHavilland DH-4B AS63789, weather was a significant factor, as was the nature of Lieutenant Webber's mission: to deliver Colonel Francis C. Marshall to his appointed destination in an on-time manner. The decision to fly was made by the pilot in command and approved by his base commander, albeit with the warning that should weather conditions prevent Lieutenant Webber from safely flying over the mountains, he was to return immediately to Rockwell Field.

The saga of the missing DH-4B was covered extensively in newspapers of the day, but it was not forgotten entirely after the missing plane was found. On May 23, 1923, a group of officers and civilian workers from Rockwell Field, led by Prentice V. Reel, visited the crash site with the intention of constructing a permanent memorial. They packed bags of concrete, shovels and all manner of tools necessary to complete the task. The focal point of the monument was the remarkably intact Liberty engine. Reel directed his volunteers to encase the base of the engine in concrete, the foundation of which would include small pieces of wreckage and a bronze plaque that read:

IN MEMORY OF
COL. F.C. MARSHALL
AND
FIRST LT. C.L. WEBBER
WHO FELL AT THIS SPOT
DEC. 7, 1922

Following the completion of the monument, a memorial service was held honoring the memory of Lieutenant Webber and Colonel Marshall. Another visitation was made a few days later by Major Arnold, Reel and four other army officers. Their mission was to install a three-foot-long sealed tube with the names of all the officers and enlisted ranks from Rockwell Field who participated in the search effort for the missing DH-4B. Also included in the tube were newspaper articles describing the search and recovery missions. Major Arnold sent a letter and photographs to the father of Lieutenant Webber in an effort to ensure that his son's loss would not be forgotten.

The land where the crash had occurred was privately held in 1922, but in 1933, it was sold to the California Department of Beaches and Parks, and the Cuyamaca Rancho State Park was established. To make the new park more accessible to visitors, the Civilian Conservation Corps constructed not only facilities but hiking trails as well. One of these trails was the Japacha Ridge Trail that connected the Green Valley Picnic Area on present-day Highway 79 with the airplane monument site. In 1968, the monument site was remodeled by California State Parks to include a new foundation for the Liberty engine. Artifacts placed in concrete in 1923 were removed and taken to the park headquarters; sadly, all were destroyed during the 2003 cedar fire that ravaged more than 800,000 acres of San Diego County lands.

The author, his wife, son and daughter hiked to the DH-4B crash site and memorial from the Green Valley Picnic Area via the West Monument Trail along Airplane Ridge in the early winter of 1982. Surprisingly, several inches of fresh snow blanketed the crash site. The Liberty engine was the focal point, drawing everyone's attention. Nearby, a few pieces of wire protruded from the snow-covered ground. We stood in respectful silence for several minutes surveying the site and the forest that surrounded it. Later, we learned that this is the oldest aircraft crash site monument in a remote location in the state of California. The author recommends that you take a walk into the past and pay your respects in this secluded place where, so long

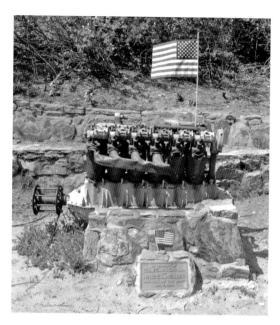

A Liberty engine from DH-4B at Japacha Ridge Memorial site in Cuyamaca State Park, circa 2015. *Photo by David Lane.*

ago, time stopped for two army officers. They lost their lives while in the line of duty. Their memorial marker and the trail to the site are clearly visible on Google Earth at 32 55 15.46 N, 116 35 18.21 W, at 4,748'.

Midair collisions were a constant risk in the skies over San Diego County. The vast majority of these accidents involved military aircraft engaged in formation flying and dogfighting practice. Between 1920 and 1940, there were more than twenty-five fatal midair accidents. In an effort to reduce the probability of midair collisions, the military aircraft of the day used high-visibility paint schemes such as chrome yellow on the tops of all wing surfaces and many tail assemblies as well. Pilots were instructed to use the "see and be seen" rule at all times, and in multi-seat aircraft, crewmen were to be on alert, especially when flying in formation.

The Vought O2U two-seat biplane was popular with navy, marine and coast guard pilots. Its name, Corsair, betokened aerial adventures. The Vought Corporation built 167 O2U Corsairs between 1927 and 1928. The Corsair was powered by the Pratt & Whitney R-1340 engine, which developed four hundred horsepower, and carried a crew of two: a pilot and an observer/gunner. The O2U could be fitted with wheels or floats and had a maximum speed of 150 miles per hour. The fuselage was made of tubular metal, and the wings were of wood construction. The entire aircraft was fabric covered except around the forward fuselage, where aluminum was

used. "O" stood for observation, "2" for type 2 of the design and "U" was the letter assigned by the navy for all Vought aircraft for navy, marine and coast guard use.

On April 19, 1929, two O2U-2 Corsairs were returning to North Island following gunnery practice near Oceanside when they collided at an estimated altitude of four hundred feet. Both aircraft spun into the mudflats on San Diego Bay. Three naval officers were killed instantly, and an enlisted radioman survived briefly and succumbed to his injuries en route to the hospital. Another pilot in the number four position reported that the accident occurred just as the aircraft were turning to make their landing at North Island, when the aircraft in the number three position turned into the leader with fatal results. The O2U-2s, Bu No A-8105 and Bu No 8117, were assigned to VS-3B (Scouting Squadron 3B) aboard the aircraft carrier USS *Lexington*.

The San Diego area was the scene of another midair collision on April 29, 1929, with a commercial airliner involved for the first time in American aviation history. Maddux Airlines was established on September 2, 1927, and began service with flights from the Los Angeles area to San Diego, San Francisco, Oakland, Fresno, Phoenix and the Agua Caliente Casino in Baja California. Maddux Airlines flew the all-metal Ford Tri-motor, capable of

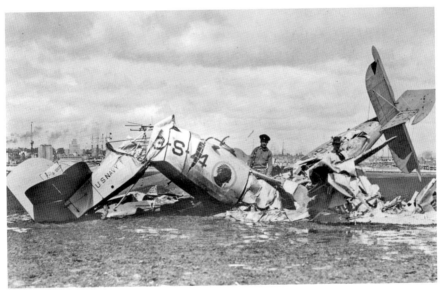

The tangled wreckage of two Vought O2U-2 Corsair navy observation aircraft that collided in flight on April 19, 1929, killing four crewmen. *San Diego Air & Space Museum.*

carrying twelve to fifteen passengers and a crew of two at 105 miles per hour cruising speed. The Ford was rugged and dependable, and its high wing design afforded passengers an excellent view of the sights below. The Ford 5-AT-B was powered by three Pratt & Whitney R-1340 Wasp radial engines, each developing 420 horsepower.

On Sunday morning, April 21, 1929, Maddux Airlines Ford 5-AT-B NC-9636 departed San Diego Airport en route to Phoenix, Arizona. Chief pilot Maurice H. Murphy and assistant pilot Louie D. Pratt were flying three passengers: Arturo Guajardo; his daughter Amelia of San Diego; and Phoenix resident Cecilia Kelly.

The airliner had only been in the air a few minutes when it was joined by US Army Reserve lieutenant Howard W. Keefer flying a Boeing PW-9D serial number 28-037 based at Rockwell Field. The PW-9D had a maximum of 155 miles per hour and was powered by a Curtiss 435-horsepower D-12D Vee-in-line piston engine.

As the Ford Tri-motor flew over downtown San Diego, the PW-9D began to fly next to, then below and then above the airliner, putting on a show for the passengers and people enjoying a Sunday outing at Balboa Park. Golfers who looked up from their games at the Balboa Park Golf Course saw the PW-9D seem to drop down on top of the tri-motor, causing a terrible noise as fatal damage was instantly done to both aircraft. With the port wing separated from the army fighter, Lieutenant Keefer jumped from the cockpit and pulled the ripcord on his parachute. But as the chute opened, it became entangled with the falling debris of the PW-9D, carrying the pilot to his death. For a few seconds, it appeared that the Maddux Airliner was attempting to return to San Diego Airport despite the damage inflicted by the collision. Witnesses on the ground hoped the crippled Ford might make it back safely.

Eyewitness accounts varied greatly depending on their vantage points. Navy officer Lieutenant J.E. Armstrong described the collision: "For a second the Maddux plane held its course. Then I saw the tail flutter. Somehow, the tail got above the nose of the ship. A wing peeled back and it slipped at a forty-five degree angle to the ground. It remained right side up until it fell close to the ground, then it keeled over on its back and fell like a piece of paper." There was no explosion or fire as the inverted Ford Tri-motor struck the ground with a thud, coming to rest at the edge of an arroyo in the Wabash District of East San Diego. The nose-mounted engine was found nearly a quarter of a mile from main impact, causing speculation that it had been knocked off the airliner by the collision. The collision had occurred about two thousand feet above ground level (AGL) in clear and stable air conditions.

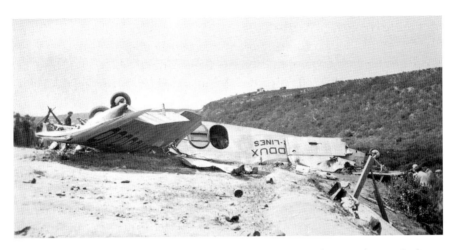

The upside-down wreck of the Maddux Airlines Ford 5 AT-B Tri-motor that crashed following a collision with an army fighter plane on April 21, 1929. *San Diego Air & Space Museum.*

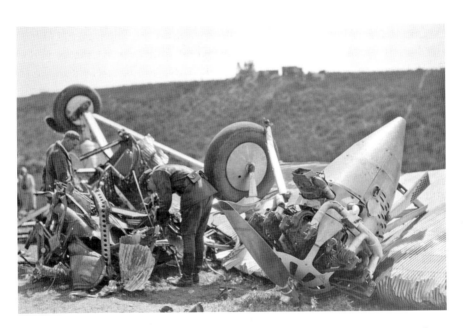

Men examine the wreckage of Ford Tri-motor NC-9636, in which three passengers and two pilots died on April 29, 1929, after being struck by army Boeing PW-9 fighter aircraft. *San Diego Air & Space Museum.*

Hundreds of people rushed to the crash site, many horrified to see the pilots dead in the cockpit and a male passenger deceased within the fuselage. What they had not expected to find were two female passengers still alive. Nineteen-year-old Amelia Guajardo died en route to the hospital, and twenty-one-year-old Cecilia Kelly died at Mercy Hospital. Souvenir hunters descended on the wrecked airliner and the debris of the army fighter, removing parts and personal effects until the police arrived and cordoned off the area. Shortly thereafter, plans were made to remove the remains of both aircraft. The recovery was accomplished by the army and personnel from Maddux Airlines.

The inquest that followed found—and the army accident report concurred—that San Diego's worst air disaster to that date was caused by Lieutenant Howard W. Keefer's actions on April 21, 1929. Representatives of Maddux Airlines demanded that military aircraft be restricted from flying close to or stunting near commercial aircraft.

San Diego County was the scene of two other fatal aircraft accidents within a few days. The first was the midair collision of two navy observation aircraft on April 19 that claimed four lives, and the other on April 20, 1929, killed J.B. Browning, who crashed forty miles north of San Diego while flying an aircraft of his own design.

Maddux Airlines would lose another Ford Tri-motor on January 19, 1930. This time it was a model 5-AT-C, NC-9689 en route from Agua Caliente Casino in Baja California to Grand Central Air Terminal in Glendale, California. This accident became the worst air disaster in San Diego County, killing the flight crew of two and all fourteen passengers. Dense fog was a factor and contributed to flight crew disorientation. NC-9689 had exploded on impact a few miles north of Oceanside, west of Highway 1, on open ground. Charles Lindbergh was recruited to conduct an inquiry into the cause of the accident, and not surprisingly, weather was cited as the primary cause.

Developments in instrument and radio technologies coupled with instrument flying training would gradually help to make civil, commercial and military flying safer. Nevertheless, the aforementioned developments were not yet in place when navy lieutenant Wallace B. Hollingsworth and his observer/gunner aviation machinist mate, third class Albert O. Pierson, were posted missing on November 13, 1930. They were returning to North Island following a flight from Riverside County in formation with navy lieutenant Robert J. Fuller and his crewman aviation machinist mate J.M. Wood. Both aircraft were Vought O2U-3 Corsairs assigned to a fleet observation squadron at North Island.

A Vought O2U-3 Corsair similar to one flown by navy lieutenant Wallace B. Hollingsworth on November 13, 1930. *San Diego Air & Space Museum.*

Weather along the flight route included low clouds and fog. The Corsairs soon became separated, with Lieutenant Fuller flying into a box canyon, forcing him to make a crash landing on Red Mountain near Fallbrook in northern San Diego County. Miraculously, both Fuller and Wood survived with minor injuries.

The next day, after the fog and clouds had burned off, the wreckage of Lieutenant Fuller's O2U-3, Bu No A-8272, was found in Rainbow Valley by search planes from NAS San Diego. Sadly, both Lieutenant Hollingsworth and his observer/gunner were found dead in the smashed remains of their aircraft.

As the 1930s progressed and air traffic increased in the skies over San Diego County, locals began labeling the area the "Air Capital of the West." As mass formation flyovers became more common, so, too, did the exhilaration among both servicemen and civilians alike. By this time, the majority of the aircraft that people were seeing overhead were navy, marine or new production planes on test flights from Lindbergh Field. However, the presence of army aviation had not disappeared entirely, as evidenced by the loss of a Consolidated PB-2A fighter aircraft on April 21, 1936. The PB-2A

is unusual in that only fifty were built. The designator "PB" stood for Pursuit Bi-place, meaning a two-seat fighter aircraft with a pilot and a gunner aft.

PB-2A serial number 35-008 was involved in the accident, and it was factory fresh, having just been delivered to the army air corps for assignment to the Twenty-seventh Pursuit Group at Selfridge Field, Michigan. The pilot was Captain Walter E. Todd, and his passenger was Lieutenant Lawrence R. Olmsted Jr., assigned to the army air corps reserve. Captain Todd was practicing a standard stall maneuver at seven thousand feet over Camp Kearny on Otay Mesa when the PB-2A entered a spin from which he could not recover. At four thousand feet, Captain Todd ordered Lieutenant Olmsted to bail out, which he did, but only after the pilot had departed the aircraft at an altitude of only two thousand feet.

Captain Todd's parachute deployed normally, and he landed safely, but Lieutenant Olmstead's parachute opened too late, and he died on impact with the ground. The PB-2A spun in and remained essentially intact without exploding or catching fire a scant twenty yards from the lieutenant's body. The accident investigation team criticized the pilot for allowing the PB-2A to spin, and the death of Lieutenant Olmstead was attributed to possibly waiting too long before deploying his parachute, fearing he would be hit by the spinning aircraft.

The Boeing F4B-4 was a fighter aircraft designed to operate from aircraft carriers, and it was similar to the Boeing P-12E flown by the army air corps in the 1930s. The F4B-4 was small, maneuverable and fast for its day, with a maximum speed of 188 miles per hour. The F4B-4 was powered by a 550-horsepower Pratt & Whitney R-1340-16 radial engine. Ninety-two F4B-4s were manufactured at the Boeing plant in Seattle, Washington, in 1932–33.

Navy lieutenant (jg) L.Q. Forbes was assigned to ferry Boeing F4B-4 Bu No 9261 from Norfolk, Virginia, to North Island. His last stop in the cross-country flight prior to departing for North Island was Yuma, Arizona. After a lunch break, and with his fighter refueled, Lieutenant Forbes departed Yuma at 1:00 p.m. on February 13, 1937. At 2:06 p.m., witnesses saw the F4B-4 near Jacumba, where it circled several times and then headed toward the cloud-enshrouded Laguna Mountains, where other eyewitnesses saw and heard the navy fighter dart in and out of the clouds.

When Lieutenant Forbes failed to arrive at North Island as scheduled, a ground search was initiated on February 14, and the smashed wreckage of Bu No 9261 was located that day at 12:30 p.m. just below the crest of the snow-covered Laguna Mountains. The body of Lieutenant Forbes was found

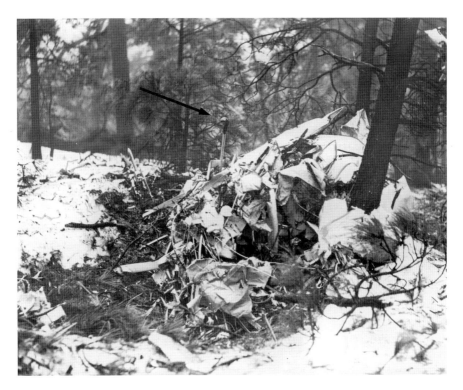

A demolished navy Boeing F4B-4 that crashed in the Laguna Mountains on February 13, 1937. Note the arresting hook protruding from the center of wreckage. *Courtesy AAIR.*

in the crushed cockpit, his hands still gripping the control stick. He had died instantly in the line of duty. The force of the impact had thrown the Pratt & Whitney engine fifty yards from the crash site. The post-crash investigation showed that the F4B-4 had dived into the ridge, shearing off the tops of pine trees before plunging into the ground. One of the only recognizable parts of the F4B-4 was the arresting hook used for carrier landings.

Lieutenant (jg) L.O. Forbes was twenty-five at the time of his death. He had been married just six months before the crash, and his young wife had been waiting for him to arrive at their cottage in Coronado on that cold Saturday in February 1937. The accident report cited pilot judgment and other factors, including weather and possible icing conditions.

A non–weather related crash happened on August 7, 1938, involving a Grumman biplane fighter assigned to Marine Fighter Squadron VMF-2 at North Island. The pilot was twenty-six-year-old Second Lieutenant Horace P. Houf, USMCR. Lieutenant Houf was assigned to fly a combat

tactics training mission about twenty-five miles east of San Diego. His Grumman F3F-2 Bu No 1038 was powered by a Wright R-1820-22 engine that developed 950 horsepower, giving the little fighter a top speed of 350 miles per hour. The F3F series had no formal name, but pilots often referred to it as the "Barrel" because of its barrel-like fuselage. The F3F design included retractable landing gear and an enclosed cockpit, and it would be the navy's last production biplane fighter. The age of the monoplane had already begun, and by 1941, all surviving F3Fs were assigned to training units.

At around 10:45 a.m., people living in the rural hills about five miles southeast of El Cajon first heard and then saw the F3F-2 twisting and turning above them. Witnesses thought the pilot appeared to be practicing various maneuvers when he suddenly pulled up, stalled and entered a spin that Lieutenant Houf recovered from, but he did not have enough altitude to successfully pull out of the dive. The F3F-2 struck the ground, killing the pilot, and burst into flames, touching off a brush fire that took several hours to contain.

The accident report stated that the pilot should have commenced his maneuvers at a higher altitude. Witness statements estimated that Lieutenant Houf was flying about three thousand above ground level at the time the aircraft stalled, perhaps while performing a hammerhead.

Second Lieutenant Horace P. Houf, USMCR, was unmarried at the time of his death. He was survived by his father.

The Consolidated PBY "Catalina" series of flying boats and amphibians was manufactured and served operationally in San Diego at North Island with navy long-range patrol and training squadrons and with the coast guard for search, rescue and patrol duties. More than three thousand PBYs were built, and they served with distinction in every theater of operations during WWII. The PBY remained in US military service from 1936 to 1957.

The first major accident involving the PBY was a nighttime midair collision near San Clemente Island on February 2, 1938, that destroyed two PBY-2 aircraft, with the loss of eleven lives, but there were three survivors, all injured seriously. Both aircraft involved in this tragedy were assigned to Patrol Squadron VP-11, based at North Island.

Prior to the United States' entry into WWI, the navy began construction of the first global radio transmitter facility on Chollas Heights, about seven miles east of North Island. The station became operational in 1917 using powerful transmitters and three six-hundred-foot-high transmission towers. The tower height required a system of cables to keep the towers stable,

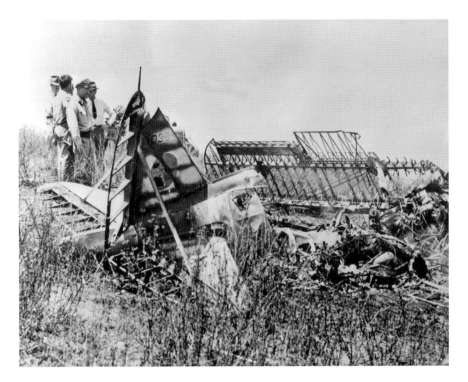

The burned wreck of the Grumman F3F-2 in which Second Lieutenant Horace P. Houf, USMCR, was killed on August 7, 1939. *Courtesy Aircraftwrecks.com.*

especially in high winds. The towers had red warning lights, and they were marked on air navigational charts as a potential hazard to low-flying aircraft.

On September 7, 1939, a flight of six PBY-3 aircraft assigned to Patrol Squadron VP-12 was returning to North Island at 9:00 p.m. following a night division training flight. The last PBY making its approach for a water landing on San Diego Bay was PBY-3 Bu No 0905 with a crew of six.

The PBY-3 pilot, Lieutenant Alden H. Irons, USN, radioed North Island at 9:13 p.m. indicating that he was north of San Diego and he was going to descend below the overcast to make his landing approach. Visibility below the coastal clouds was ten miles. No further messages were received because at 9:15 p.m., PBY-3 Bu No 0905 collided with a cable on one of the six-hundred-foot towers at the Chollas Heights Naval Radio Transmitting Station. The tower cable tore through the outer right wing of the PBY-3, but the stricken aircraft continued flying for one thousand feet before crashing and exploding on open ground, killing all on board. The naval investigating team determined that the pilot did not know his location when he descended

A Consolidated PBY-3 Catalina flying boat similar to one that crashed on Chollas Heights on the night of September 7, 1939, killing the navy crew of six. *San Diego Air & Space Museum.*

through the clouds and that as he flew toward North Island, the radio tower warning lights blended with the San Diego city lights.

Alden H. Irons graduated from Annapolis in 1931. He went on to earn his wings of gold in 1934, becoming naval aviator #4039. He is buried at Arlington National Cemetery. Other crewmen aboard Bu No 0905 were copilot Ensign L.W. Latremore, Chief Aviation Machinist Mate Frank Vukovich, Machinist Mate Third Class H.O. Wilson, Aviation Ordnance Man Second Class V.E. Morris and Radioman Third Class H.G. Berry.

The navy adopted dive bombers in the 1920s, starting with the Curtiss Helldiver series of biplanes. In 1941, the Curtiss SBC-4 was still in first line service with navy and marine squadrons. The Vought Corporation also built the SBU series of biplane dive bombers and was the first to build an operational monoplane dive bomber characterized by the Vought SB2U series. Known by its popular name Vindicator, the SBU-1, 2 and 3 served with both navy and marine squadrons. The marines flew

the Vindicator in battle in June 1942 from Midway Island, where their gallant crews suffered terrible losses.

On October 19, 1939, a flight of Vindicators from Navy Bombing Squadron 2 (VB-2) was participating in dive-bombing practice when SB2U-2 Bu No 1353, piloted by Ensign Theodore Smith and his gunner, RM 2/c Leland Hall, collided with SB2U-1 Bu No 0753, flown by Ensign Harold Pence and his gunner, AOC Edward Eakins. Both aircraft plunged to the ground and burst into flames, killing all on board. The collision occurred between Lake Murray and San Diego State College (now CSUSD). There were no eyewitnesses because patchy fog obscured the area. The hulks of mangled Vindicators burned out before firefighters could arrive at the scene. The grim task of recovering the dead started later that day. The Vindicators were part of a flight of twelve based at North Island, but their fleet assignment was aboard the aircraft carrier USS *Lexington*. In the days following the accident, the members of Bombing Squadron VB-2 mourned the loss of four shipmates. The youngest was twenty-two, and the senior man was thirty-three.

How to prevent midair collisions continues to be a topic that squadron safety officers and flight instructors emphasize to the present day. Midairs continue to occur in spite of educational efforts and technological advancements but, thankfully, at a much lower rate.

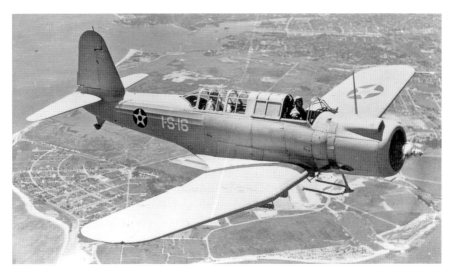

A Vought SB2U-2 Vindicator, navy dive bomber, two of which collided over Black Mountain on October 19, 1939, killing four crewmen. *San Diego Air & Space Museum.*

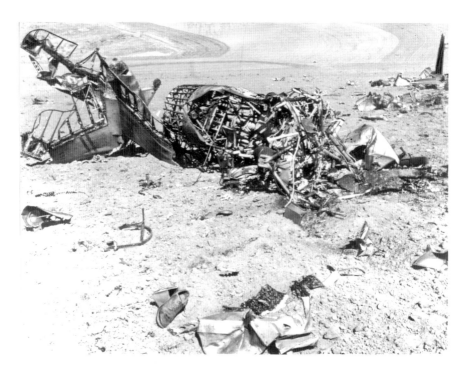

The charred remains of the Vought SB2U-2 Vindicator assigned to navy bombing squadron VB-2 that crashed on Black Mountain on October 19, 1939. *Courtesy AAIR.*

With the start of WWII in Europe and the continuing efforts by the Empire of Japan to conquer the Republic of China, the United States of America continued to expand its armed forces. Introducing improved weapons, stockpiling supplies of war-related materials and intensifying training and readiness protocols became the hallmarks of 1940–41. Neutrality patrols on the eastern seaboard and the Panama Canal Zone were fully operational by 1940 as tensions continued to rise worldwide.

The best torpedo bomber and carrier-based level bomber available to the US Navy in 1940 was the Douglas TBD-1 Devastator. The protoype TBD-1 made its first flight in 1935, and the first production aircraft reached operational squadrons in the fall of 1937. All 130 had been delivered to the navy by the fall of 1939. The TBD-1 was powered by a nine-hundred-horsepower Pratt & Whitney R-1830-64 radial engine and carried a crew of three: pilot, torpedo officer/navigator and gunner. The TBD-1 was equipped with one forward-firing .30-caliber and one flexible aft-mounted .30-caliber gun. In addition, one externally mounted one-thousand-pound torpedo or single one-thousand-pound bomb could be carried.

The top speed of the TBD-1 was 206 miles per hour, but the cruising speed was a modest 128 miles per hour. In WWII combat, the Devastator would prove to be more effective as a level bomber than in successfully delivering torpedoes.

In 1940, the navy had four torpedo squadrons—VT-1, VT-2, VT-5 and VT-6—and all were assigned to a Carrier Division, a key part of the Pacific Fleet. North Island, San Diego, and Pearl Harbor, Hawaii, were the land-based homes for most of these squadrons. TBD-1 Bu No 0292 and TBD-1 Bu No 0373 were both assigned to Torpedo Squadron 3 (VT-3) to the aircraft carrier USS *Saratoga*. When not aboard ship, flight crews needed to maintain proficiency by flying on a regular basis. These flights included practicing takeoffs, landing, instrument flying, ordnance delivery, defending against enemy aircraft and navigational training.

January 12, 1940, was an exceptionally clear day, perfect for an instrument training flight, in which the pilot would put a hood over his cockpit, with the middle seat occupied by a second pilot who could fly the Devastator acting as the safety pilot. The middle seat or station was equipped with bomb aiming and torpedo release switches, as well as flight controls. The third seat was occupied by the radio operator/gunner. Even with the dual controls, instrument training flights required a second aircraft to monitor the aircraft whose pilot was under the hood.

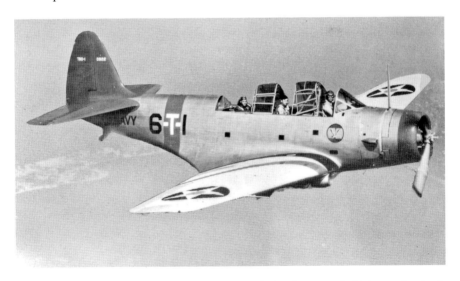

A Douglas TBD-1 Devastator three-seat navy torpedo bomber, two of which were involved in a fatal midair collison on January 12, 1940. *San Diego Air & Space Museum.*

At 1:15 p.m., two TBD-1s departed North Island and flew on a northeasterly heading toward the rugged mountains and desert of the Anza Borrego State Park. TBD-1 Bu No 0373 was flown by Ensign Harold N. Funk practicing instrument flying under the hood. Behind him in the middle seat was the instructor pilot, naval aviation pilot James A. Crowson. The third seat was occupied by Radioman Third Class Elmer E. Jackson. TBD-1 Bu No 0292 was flying as the escort/safety aircraft, piloted by Ensign Walter G. Barnes. In the middle seat was Aviation Machinist Mate Second Class, NAP, Paul E. Dickson, and Radioman Second Class Charles W. Post was in the third seat. At 2:00 p.m., the Devastators were flying in a loose formation when instructor pilot Crowson took control of Bu No 0373 to allow Ensign Funk to briefly rest before continuing his instrument training. At this time, the crew of TBD-1 Bu No 0373 lost sight of Bu No 0292 and made a turn to the left and then began a turn to the right when it collided with the escorting Devastator. When Ensign Barnes flying Bu No 0292 experienced loss of rudder control, he signaled his crew to bail out, which they immediately did. However, the situation aboard Bu No 0373 was very different. Having lost its left wing tip and the entire aileron assembly, the aircraft began to spin. Funk removed his instrument training hood and tried to bail out on the left side, but centrifugal forces prevented him from leaving the cockpit, so he moved over to the right side and made good his escape. Jackson in the aft seat had preceded Ensign Funk, but Crowson remained in the middle seat, apparently pinned there by the effects of the spinning Devastator. Naval Aviator Crowson was tragically killed when his spinning aircraft crashed into a remote area of the Anza Borrego State Park.

The collision had occurred at about ten thousand feet, allowing those who had bailed out plenty of time to deploy their parachutes. A parachute landing in rugged terrain can be tricky at best. Funk sustained a serious knee injury, and Dickson, who landed near Funk, sustained abrasions from contact with the endemic cholla or "jumping cactus." Dickson tried to carry Funk to safety, but when that didn't work out, Dickson hiked to a nearby highway and hitchhiked into Ocotillo, where he organized a rescue party to pick up Ensign Funk.

Preceding Dickson into Ocotillo was Charles Post, who had suffered a sprained ankle but had managed to hobble there on his own. Post was rushed to Brawley, suffering from dehydration and shock. Meanwhile, Jackson suffered abrasions on his landing but managed to walk to a highway maintenance camp for help. Ensign Walter Barnes had not been injured and

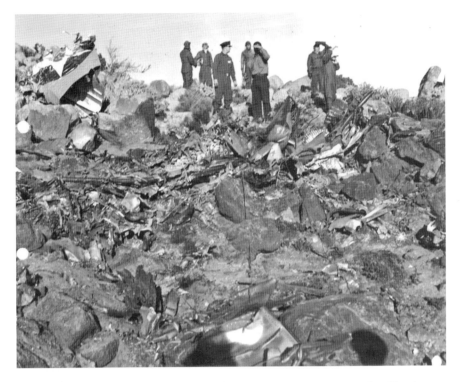

The crash site of Douglas TBD-1 Bu No 0373, lost in a midair collision, killing Naval Aviation Pilot James A. Crowson. *Courtesy AAIR.*

reached a roadway, where he flagged down a car whose driver took him to the mountain town of Julian.

In the days that followed the midair, the crash sites of the Devastators were examined by navy recovery teams for parts that might be salvageable. Very few parts were, in fact, recovered due to the rugged terrain and the demolished nature of both wrecks. On January 20, 1940, the Naval Safety Board published its findings regarding the cause of the January 12, 1940 midair. The board found both TBD-1 safety pilots at fault for flying too close together and for losing sight of each other. No blame was assigned to Ensign Funk, as he was practicing instrument flying under the hood at the time the collision occurred.

The midair of the Devastators received extensive press coverage in newspapers across the nation, but as preparation for the possibility of Untied States involvement in the war with the Axis Powers grew, the loss of two torpedo bombers in eastern San Diego became a footnote in the pages of aircraft accident history.

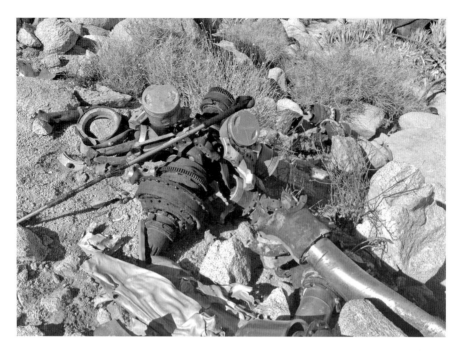

Wreckage of TBD-1 Bu No 0373 assigned to navy torpedo squadron VT-3 on a rugged mountainside in the Anza Borrego State Park, circa 2015. *Photo by David Lane.*

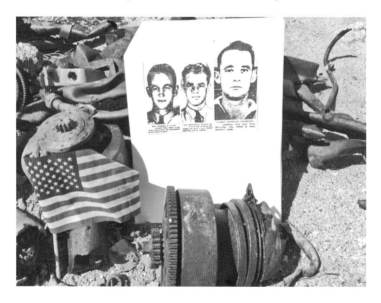

When David Lane found the crash site of TBD-1 Bu No 0373 in the spring of 2014, he displayed the American flag and a photocopy of a picture of the three crewmen in memory of their service and sacrifice on January 12, 1940. *Photo by David Lane.*

The author developed an interest in locating the TBD-1 crash sites in 1969. Newspaper articles were acquired, and the first reconnaissance mission was made in 1974, without success. In later years, additional efforts were made to scout areas where at least one of the TBD-1 wrecks might be found. Even the coroner's report for James A. Crowson offered few clues as to a location for the crash site of Bureau Number 0373. It was not until March 2014 that the author was contacted about aircraft parts being found. The parts were initially described as possibly being from an older civilian light plane, but when the hiker's photos were made available, it was apparent that the outer wingtip and aileron from TBD-1 Bu No 0373 had been located. This important discovery had been made by Don Endicott and a friend in the winter of 2014. Endicott is an Anza Borrego Desert State Park archaeology site steward and member of the Colorado Desert Archaeology Society. The crash site of Bu No 0292 was also located, thanks to Project Remembrance Team member David Lane, whose tireless efforts helped locate the remnants of one TBD-1 lost on January 12, 1940. The wreck sites of both Devastators are protected by the Antiquities Act, and locations of these historic aircraft must remain anonymous to ensure their conservation.

The military accident rate in 1940 would continue to increase as all manner of army, navy and marine flight activities accelerated against the backdrop of war in Europe and Asia.

CHAPTER 2
THE WINGS OF WAR

Few people today know that in and around the continental United States, from 1941 to 1945, more than twenty-five thousand military airmen and women were killed in flight training, testing, ferrying, transporting or patrolling our skies and shorelines just prior to and during the Second World War. In California alone, there were 8,348 accidents involving US Army Air Corps and US Army Air Force aircraft. No exact number of US Navy, Marine or Coast Guard accidents is currently available, but they are estimated to be about half that of the US Army. The navy loss rates reflect the number of aircraft assigned to or passing through California. The majority of military aviation operations within California during WWII were conducted by the US Army, but not in San Diego County, where navy and marine flight operations surpassed those of the army by a ratio of ten to one.

In an effort to modernize its air transport capabilities, the US Navy purchased five twin-engine Douglas DC-2 all-metal monoplanes with retractable landing gear and a top speed of 210 miles per hour. The DC-2 was given the naval designation R2D-1. The R2D-1 could carry twelve passengers and a crew of four that included two pilots, a radio operator and a crew chief. The navy used three of the Douglas transports, and the marines received two for flight operations within the continental United States.

On January 4, 1941, US Navy R2D-1 Bu No 9622 departed Big Springs, Texas, en route to North Island with a crew of four and seven passengers on board. Four of the passengers had parachuted from a stricken PBY Catalina flying boat on January 2, and they were being returned to San Diego along

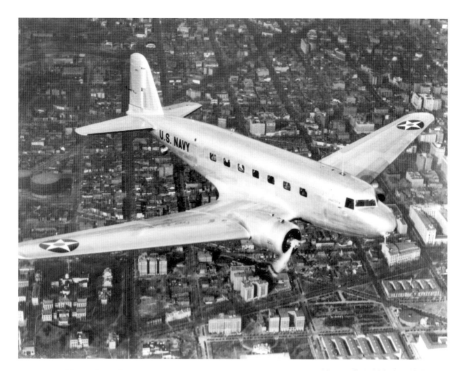

The navy Douglas R2D-1 depicted in this photograph is similar to Bu No 9622, which crashed on January 6, 1941, on Mother Grundy Peak in San Diego County. *San Diego Air & Space Museum.*

with three naval officers who had conducted the investigation into the PBY crash. Two crewmen normally assigned to Bu No 9622 missed the flight: the crew chief, because he went on leave, and the radioman, who was approved to swap his duty assignment for personal reasons.

At about 6:30 p.m., Bu No 9622 was approaching the San Diego area flying in darkness and rain showers when it struck a mountain between Mother Grundy Peak and White Mountain. The R2D-1 had come close to clearing the mountain by less than one hundred feet. Those on board had died instantaneously, and a post-impact fire consumed more than 50 percent of the wreckage. As the bodies of the victims were being removed, the PBY accident report was recovered intact, having been thrown clear by the impact. The briefcase it was in had sustained damage, but not the report within. The navy accident report cited weather and pilot error as factors in the loss of eleven irreplaceable lives and a highly valued machine.

Rugged terrain prevented the immediate removal of the R2D-1 wreckage from the mountain, but in later years, aluminum salvagers smelted the metal

on site and packed out the ingots. This type of freelance salvage would become commonplace in remote areas of San Diego County in the years that followed. Wildfires over time have further degraded the site, but landing gear assemblies, engine blocks and stainless steel parts still survive at the rugged boulder-strewn crash site where eleven navy officers and enlisted men died so long ago.

The navy had recognized the importance of the dive bomber by the early 1930s, but by the end of the decade, the many dive-bombing squadrons were still equipped with biplane aircraft that were rapidly becoming obsolete. New monoplanes began to appear, including the Vought SBU Vindicator and the all-metal Northrop BT-1, fifty-four of which were delivered to navy squadrons by 1938. The primary armament of this new design was a single one-thousand-pound armor-piercing bomb. A single .50-caliber machine gun firing forward and a single .30-caliber machine gun firing aft rounded out the weapons suite. The most important aspect of the BT-1 (no popular name given) was the perforated diving flaps that allowed the aircraft to achieve a near vertical dive. The bomb was mounted on a trapeze that, when released,

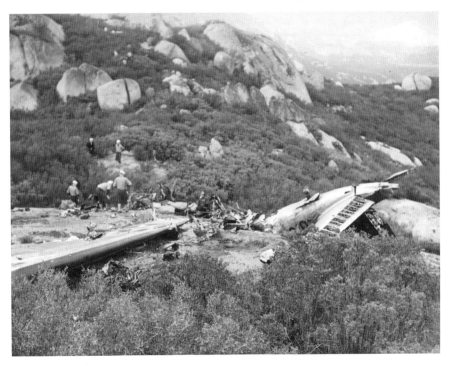

Navy recovery teams work at the crash site of Douglas R2D-1 Bu No 9622, where eleven navy men were killed in a weather-related accident on January 6, 1941. *Courtesy AAIR.*

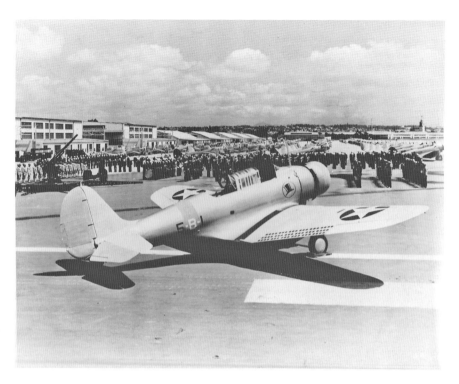

Two Northrop BT-1 dive bombers were involved in a midair collision on February 24, 1941, killing four naval air crew members. *San Diego Air & Space Museum.*

swung clear of the propeller, allowing a high degree of bombing accuracy. The BT-1 was the precursor of the Douglas SBD Dauntless that would help save the day at the Battle of Midway in June 1942. Both the BT-1 and the SBD were designed by Ed Heinemann, whose engineering genius would also create the A-4 Skyhawk, known as "Heinemann's Hot Rod."

On the night of February 24, 1941, two BT-1s were lost in unrelated accidents that claimed the lives of four naval aviators. The first crash occurred at sea off Carlsbad when BT-1 Bu No 0608 apparently entered a dive from which it did not recover, exploding in a fireball as it struck the ocean. The second BT-1, Bu No 0626, was found on February 25 five miles east of La Jolla on rugged and brush-covered Kearny Mesa near San Clemente Canyon. Both aircraft were from bombing squadron VB-6, assigned to the USS *Enterprise.*

The bodies of Ensign G.S. Maxwell, USNR, and Seaman Second Class E.W. Clary were recovered, but Ensign W.A. Daniel, USNR, and AMM Third Class E.S. Lemort were posted missing and were never recovered.

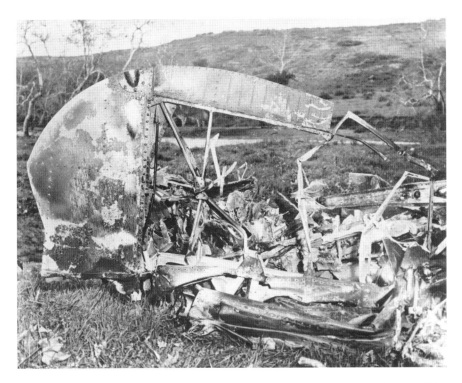

Burned wreckage of navy Northrop BT-1 Bu No 0626, which crashed four miles east of La Jolla on February 24, 1941, killing both crewmen. *Courtesy AAIR.*

Only an oil slick and small debris were observed on the Pacific Ocean between the beach communities of Encinitas and Carlsbad.

From January 1, 1941, to February 24, 1941, fifteen naval aircrew and one army pilot were killed in San Diego County air crashes. March would see no letup in aircraft accidents. Where darkness may have been a factor in the loss of the BT-1s, weather would be a factor in the loss of Douglas TBD-1 Bu No 0323, assigned to VT-3 aboard the USS *Saratoga*.

Five TBD-1 Devastators departed North Island on the morning of March 11, 1941, for a routine training flight that proceeded normally until the flight entered cumulus clouds above ten thousand feet. Because extremely rough air was encountered, the flight leader ordered all aircraft to return immediately to base. Moments later, TBD-1 Bu No 0323 was seen spinning out of the clouds by a state fish and game warden from his vantage point on Highway 79. Only one man managed to escape the doomed aircraft by parachute. The pilot was Ensign Walter G. Barnes, who had cheated death in the January 12, 1940 midair of two TBD-1s over Anza Borrego Desert

State Park. Ensign Barnes's radioman, AMM Third Class Ralph Goff, and gunner, AMM Third Class Dilland D. Doga, were killed when the TBD-1 crashed and burned seven miles north of Warner Springs.

Ensign Barnes sustained minor injuries bailing out and landing, but he still managed to walk first to the TBD-1 crash site, where he found his crew deceased, and then on to a house where the owner gave him a ride into the town of Ramona.

The navy accident report cited weather as a factor and vertigo experienced by the pilot as the primary cause of the crash. Ensign Barnes told investigators that he inadvertently stalled the TBD-1 and entered a spin from which he could not recover. Centrifugal forces had apparently pinned his crew in their seats, making bailouts impossible.

The Japanese attack on Pearl Harbor on December 7, 1941, plunged the United States of America into the Second World War. Leaves were canceled, and all West Coast military facilities were placed on high alert. Production of war-related materials and supplies continued to accelerate, and reinforcements were rushed to embarkation points such as San Diego, where so many Pacific Fleet ship and air assets were based.

One of the first military losses in 1942 occurred on January 1, when an army air force Consolidated LB-30, an early version of the B-24 Liberator, developed a landing gear problem as it approached Lindbergh Field. The LB-30 had departed Fresno, California, earlier in the day, and after the crew spent almost three hours unsuccessfully attempting to lower the landing gear, the aircraft began to run out of fuel. With only a few minutes to spare, the pilot ordered all crew members to bail. The pilot flew the LB-30 south toward Imperial Beach before he departed the aircraft at 9:20 p.m.

All five crewmen had bailed out successfully, and only one man sustained a minor injury. To the astonishment of the crew, the LB-30 landed itself in the surf near Imperial Beach. The aircraft remained mostly intact, having landed in perfect trim. The wreck was salvaged, and the crew was returned to duty with the Ninety-seventh Bomb Squadron at Hammer Field near Fresno, California.

Included in this buildup were aircraft manufactured by the Grumman Aircraft Corporation of Bethpage, Long Island, New York. Grumman had two new aircraft designs that the navy and marine corps wanted ASAP. The first was the F4F Wildcat fighter, and the second was the TBF Avenger, torpedo bomber. The fastest way to move these aircraft was to fly them from the factory directly to the air stations where they were needed. Weather permitting, flights of four or more Grumman products were being

dispatched on a daily basis. The distance from the Bethpage factory to a West Coast delivery point could take three or four days depending on weather conditions and other factors. Nonetheless, on-time deliveries were emphasized in the frantic days of early 1942.

On the morning of February 13, 1942, a flight of four factory-fresh Grumman F4F-4 fighter aircraft departed Tucson, Arizona, on the next leg of their cross-country journey, with one stop in Yuma before departing Arizona en route to San Diego Naval Air Station. The flight to this point had been uneventful and on time, but the weather forecast for the last 150 miles included a warning about the approach of a winter storm front bringing rain and snow to the higher elevations of San Diego County mountains. None of the four ferry pilots had made this trip before, and they were all newbies, fresh from training. Their flight experience, including instrument training, had been limited, and the majority of their flight time was confined to Florida and the East Coast of the United States.

Following a lunch break in Yuma and checking the latest weather report, the pilots decided to complete the final 150-mile leg of their cross-country flight by following Highway 80 (now Interstate 8). They had hoped, apparently, that by following the highway, they could safely fly over the Laguna Mountains, arriving at North Island within one and a

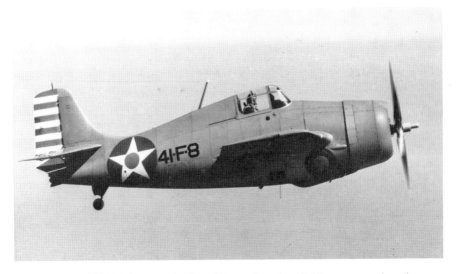

The Grumman F4F Wildcat was the finest fighter aircraft available to navy and marine corps squadrons in 1941–42. Following the Japanese attack on Pearl Harbor, factory-fresh Wildcats were rushed to San Diego for deployment to the war zone. Not all of them made it. *San Diego Air & Space Museum.*

quarter hours. Less than thirty minutes after departing Yuma, the flight encountered strong headwinds, but they continued on course until they were engulfed by storm clouds. At this point, two of the F4F-4s were able to stay in formation. The lead pilot is believed to have been Ensign Carl W. Peterson, with Ensign Samuel Kime just a few yards off his starboard wing. Ensign Julian Locke D'Este and Ensign Charles D. Davy had become separated from the leader earlier in the flight by clouds, headwinds, turbulence and icing conditions generated by the winter storm front all four pilots were now battling.

When the flight of F4F-4s failed to arrive at North Island, calls were made to Yuma and other airfields in the hope that the flight had landed safely to wait out the storm. Sadly, this was not the case, but one F4F-4, Bu No 5049, did make a successful forced landing near the town of Ramona. The pilot was Ensign Charles D. Davy, USNR. Ensign Davy described his harrowing flight after departing Yuma; losing sight of his flight; and flying to Blythe, California, where he landed and took on fuel. He then resumed his flight to San Diego, fighting headwinds and clouds and narrowly missing a mountain, with wings icing up as he climbed, intending to bail out. Suddenly, a hole in the clouds appeared and he dove through it. Panicked and nearly out of gas, the young ensign made an emergency landing on a dirt road, damaging the left landing gear assembly, bending the propellers and demolishing the starboard wing tip. Only six gallons remained in his gas tank. Exhausted by his ordeal, Ensign Davy was driven to Ramona, where a call was made to NAS San Diego. Marine guards were dispatched to protect the forlorn Wildcat fighter until it could be recovered for salvage or repair.

On February 14, teams began searching for the three missing Wildcats and two army aircraft that had disappeared on the thirteenth while on an unrelated training mission. Snow had blanketed the Laguna Mountains, and intermittent storms made the search missions all the more difficult. For seventeen days, search planes flew when weather permitted, and ground teams trudged through pine forests, areas of dense chaparral and boulder-strewn canyons without result. Finally, on March 5, 1942, the search was suspended, but the cost of the effort had been high, with loss of two navy airmen and their North American Aviation SNJ-2 search aircraft.

On February 14, three navy search aircraft departed NAS San Diego to look for the missing F4F-4 Wildcats and their crews. They were tasked with searching the rugged Santa Rosa Mountains that rise to altitudes above eight thousand feet. It was during this search mission that SNJ-2 Bu No 2549 vanished with its pilot, Ensign William W. Page, and his observer, Ensign

Left: Ensign Julian Locke D'Este Jr., one of three F4F-4 Wildcat pilots to lose his life on February 13, 1942, in eastern San Diego County. *Courtesy Richard Mosehauer.*

Right: Ensign Arthur Samuel Kime, one of three F4F-4 Wildcat pilots to lose his life on February 13, 1942. *Courtesy Francine Woollums.*

Luis M. Winn. Weeks of search flights over the Santa Rosa Mountains ended without result, and because there was a war in progress, public attention about five missing navy aircrew quickly waned. Not so for the next of kin, some of whom held out hope that their loved ones had crash-landed in Mexico and were still alive, perhaps held by bandits.

How is it that four all-metal aircraft could disappear without a trace in the wilds of Southern California? There are hundreds of square miles of rugged mountains and desert lands covered in places by pine forests and at lower elevations by dense chaparral, ten to twenty feet high in places. The desert mountains, though mostly barren, are covered by large boulders; narrow, twisting canyons; and extensive areas of cholla cactus and other flora associated with the Colorado desert.

The leader of the February 14, 1942 search mission to locate the missing F4F-4s was Lieutenant Commander James F. Patterson, USN. When the search for SNJ-2 Bu No 2549 was called off, Lieutenant Commander Patterson was assigned to combat duty overseas, but when he finally returned stateside, he received permission to fly a series of search flights in the area where he thought Ensign Page might have

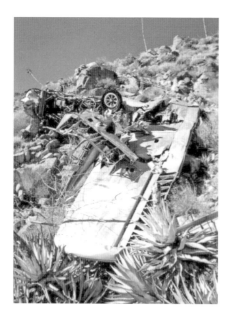

Wreckage of navy SNJ-2, lost with a crew of two on a search mission for three missing F4F-4 Wildcats on February 14, 1942. *G.P. Macha Collection.*

crashed. On September 23, 1944, he spotted what appeared to be the wreckage of the missing SNJ-2. The next day, accompanied by marine captain Myles B. Miller and a group of marines from El Toro Marine Air Station, Lieutenant Commander Patterson reached the crash site of the long-missing SNJ-2. While at the crash site, he confirmed the identity of both Ensign Page and Ensign Winn from personal effects recovered there. The hike had been an ordeal for both Lieutenant Commander Patterson and Captain Miller, as both men sustained injuries climbing in the canyon where the SNJ-2 lay, undisturbed for thirty-one months.

Years would pass until another missing aircraft would be found in San Diego County. The discovery was made by two friends who were looking for Native American artifacts when they stumbled on the smashed remains of Grumman F4F-4 Bu No 5046, flown by Ensign Julian Locke D'Este. What they saw shocked them: human remains, personal effects, machine guns, bent propeller blades and the long-silent Pratt & Whitney R-1830-86 engine that once generated 1,200 horsepower. The discovery was made on May 29, 1952, more than ten years after the three Wildcats had disappeared. The friends reported their discovery immediately, but it took time for the navy and the San Diego county sheriffs and coroner to reach the wreck site and confirm the identity of the aircraft and the pilot. On Monday, June 2, 1952, newspapers across the country ran the stories under varied titles: "Old Plane Wreck Found," "Plane Wreckage, Skeleton Found" and "Crash May Be 10 Years Old."

Ensign Julian Locke D'Este Jr.'s next of kin were notified, providing them with a measure of closure, while the Kime and Peterson families hoped that the remains of their loved ones would be found, too, assuming that they had crashed near one another. Cursory over-flights of the area where the D'Este wreck was located produced no other aircraft debris of any kind. Once again,

the trail went cold. That is, until January 5, 1955, when an Anza Borrego State Park ranger conducted a patrol into an area that he had never visited before. After nearly two hours of hiking, he spotted a shine in the distance that appeared to be the wing of an aircraft. Reenergized by this discovery, he pressed on to the crash site, where he found .50-caliber machine guns, bits of decomposed parachute silk, clothing and bone fragments. The ranger also saw boot prints of a single individual in and around the crash scene.

With darkness approaching, the ranger hiked back to his vehicle and drove to the nearest park station to report his discovery and notify the sheriff's department and the navy. Thinking the crash site was within the state park and that it was a missing aircraft did not pan out as the ranger expected. The wreck that he discovered was the F4F-4 Bu No 5046 flown by Ensign D'Este Jr. that had been discovered in 1952. Nonetheless, another complete examination of the Bu No 5046 wreckage was made by naval authorities and the sheriff's personnel.

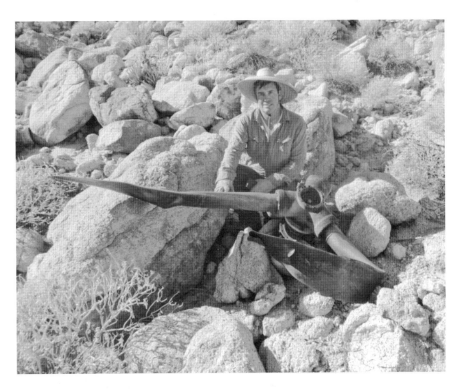

Patric J. Macha at the crash site of F4F-4 Bu No 5046, flown by Ensign Julian Locke D'Este Jr., whose remains were not discovered until May 31, 1952. *Courtesy of David Lane.*

On March 25, 1957, two men were surveying in a rugged canyon southeast of Julian when they stumbled on not one but two wrecked aircraft. The surveyors were astonished to see human remains and personal effects on the rock-strewn ground. The men hiked out to report their discovery, and the next day, marine helicopters arrived at the crash sites to begin the recovery mission. The remains of Ensign Carl W. Peterson, pilot of Bu No 5044, and his wingman, Ensign Samuel Kime, pilot of Bu No 5053, were found only yards apart. They had died instantly and next to each other, maintaining their formation against near impossible odds. They would be going home. Thanks to a pair of surveyors working in a difficult and remote place, closure could finally be achieved for the family and friends of both naval aviators who had lost their lives while in the line of duty.

Four navy ensigns had flown into a maelstrom on February 13, 1942, in a desperate attempt to clear the mountains and deliver their Wildcats safely to North Island. Ensign D'Este's crash site was a scant three air miles south of those of Ensigns Peterson and Kime, but even if they had cleared the mountains in which they crashed, the much higher cloud-enshrouded Laguna Mountains loomed ahead. A 180-degree turn to the east might have saved the day. The navy accident reports were brief, citing lack of training coupled with error in pilot judgment and the weather. What was not mentioned in the report was the pressure aircrews felt at the time to get the job done, delivering much-needed combat equipment intact and on time to assigned destinations.

The number of aircraft that crashed while being ferried within the continental United States rose dramatically in 1942. Rules were introduced in an effort to reduce these losses. Ferry flights would be accomplished only during daylight hours and never in IFR (Instrument Flight Rules) conditions, and flights of two or more aircraft would be required.

In recent years, members of the Project Remembrance Team made it a priority to locate crash sites of the once missing Grumman F4F-4s. Months of research finally paid off in 2014, when the crash site of Julian Locke D'Este Jr. was found. The site showed signs of the salvage efforts done in the 1950s, when most of the useable aluminum was smelted at the crash site and packed out by burros. For some reason, the engine block had been disassembled but not removed. The three propeller blades, an oxygen tank, parachute wrapper frame, armor plate, landing gear parts and flap sections were all photographed in situ. Also found was an interesting sheet of un-salvaged aluminum with a painted yellow X and the words "FOUND JAN 12, 1952." Of course, the date was in error and should have read May 29,

1952. After several hours documenting and photographing the remains of Bu No 5046, the team observed a minute of silence in memory of the service and sacrifice of United States Naval Reserve Ensign Julian Locke D'Este Jr., age twenty-one at the time of his death.

Following a series of solo forays into the desert mountains of eastern San Diego County, in January and February 2015, Project Remembrance Team member David Lane located the final resting places of the F4F-4s flown by Ensign Carl W. Peterson and Ensign Samuel Kime. These wreck sites, found astride each other, were located in exceptionally difficult and foreboding terrain. As with the D'Este site found the preceding year, the wrecks of Bu No 5044 and Bu No 5053 had been subjected to the aluminum reduction treatment. However, the engines, landing gear assemblies, armor plate and propeller blades still remained to be documented and

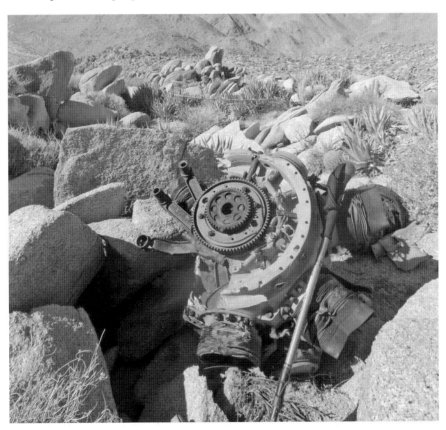

A long-silent Pratt & Whitney R-1830 engine from one of two long-missing F4F-4 Wildcats that were finally located on March 25, 1957. *Photo by Dennis Richardson.*

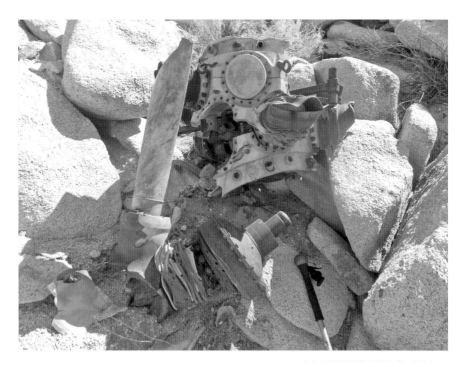

Part of the propeller assembly and R-1830 engine block from a F4F-4 that vanished on February 13, 1942. *Photo by David Lane.*

photographed. Empty cans of yellow paint were also observed, but the wing surfaces to which the yellow Xs had been applied were long gone. Before making the long hike back to his truck, Lane thought of his father, a naval aviator who had flown the Wildcat in the Second World War but had survived to return home safely.

Military aircraft losses in 1942–45 soared as advanced fighter and bomber combat training continued to accelerate in the skies over San Diego County. Many of these losses occurred at or near bombing and gunnery targets, such as Clark Dry Lake in the Anza Borrego Desert. Sadly, many navy and marine Douglas SBD Dauntless dive bombers crashed, failing to recover from their screaming dives possibly because of target fixation or pilot blackout. To this day, several of the target structures can still be seen on the lakebed. Midair collisions also continued to claim SBD flight crews, such as the November 20, 1942 loss of one navy SBD-4 Dauntless that was cut in half during a formation flight, resulting in the loss of both crewmen, with the other SBD-4 making a successful emergency landing, albeit with major damage to the aircraft.

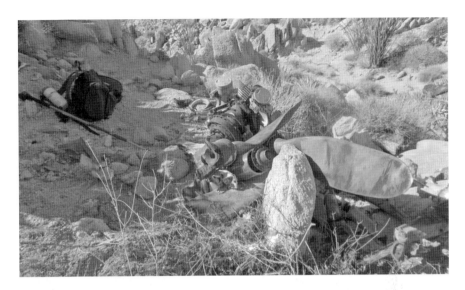

The crash site of two F4F-4 Wildcats that crashed a scant two hundred feet apart on February 13, 1942. *Photo by David Lane.*

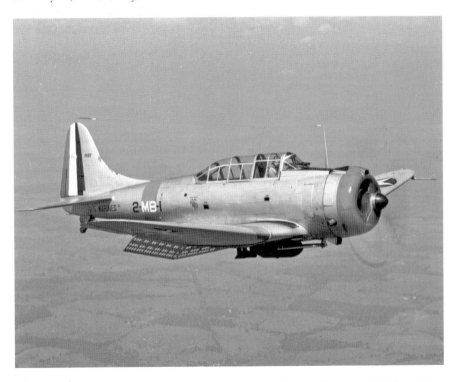

The renowned Douglas SBD Dauntless dive bomber marine markings in 1941. Many SBD losses occurred while on routine training missions in San Diego County. *San Diego Air & Space Museum.*

On August 18, 1943, two USAAF Lockheed P-38H Lightning fighters engaged in combat tactics training at eight thousand feet collided north of downtown San Diego over the Linda Vista neighborhood, with fatal results for one army pilot and three small children inside a duplex. While the pilot of the second P-38H bailed out successfully, his fighter crashed in a canyon only one hundred yards from houses on Judson Street, narrowly missing several civilians.

There were other P-38 losses over the mountain and desert areas of eastern San Diego County, including the April 28, 1943 crash southwest of Coyote Wells that killed First Lieutenant William P. Ackerman as he made a simulated strafing run. USAAF P-38H, serial number 42-66695, flown by Lieutenant George G. Redmon, disappeared on February 15, 1944. Lieutenant Redmon was in a flight of four P-38s over the Anza Borrego when he radioed that he was returning to North Island with one engine out. He was last seen entering a cumulus cloud formation over the Laguna Mountains. When no further radio messages were received, a search was initiated. Following two weeks of intensive land and air searches, Lieutenant Redmon was posted missing and presumed dead.

The Lockheed P-38 Lightning was a common sight over San Diego during WWII because the army had responsibility for the air defense of the West Coast of the United States, and the P-38 was the type assigned as interceptor because of its long range and heavy firepower that included one 20-millimeter cannon and four .50-caliber machine guns. During WWII, most Americans, from kids to adults, could identify the P-38 in flight because of the twin-engine, twin-boom design. The P-38 was often based at Camp Kearny (now Miramar Marine Corps Air Station), and they were also commonly seen at Naval Air Station San Diego, known today as NAS North Island.

The advanced training syllabus for all fighter pilots included simulated attacks against bomber aircraft. These simulated intercepts were commonly made over the mountains and deserts of San Diego County without incident until May 30, 1944, when a flight of five General Motors–built FM-2 Wildcats assigned to navy Squadron VF-36 intercepted a flight of four Consolidated PB4Y-1s assigned to navy Patrol Bomber Squadron VB-102. As the fighters engaged the bombers, an accidental collision occurred when an FM-2 Bu No 55086 dove through the flight of bombers, striking PB4Y-1 Bu No 31996 on the left wing. The PB4Y-1 and the FM-2 plunged in flames into Birch Hill, three miles south of the Palomar telescope complex. None of the eleven crewmen

Army air force Lockheed P-38 Lightning fighter, similar to one that disappeared on February 14, 1944, over the Laguna Mountains. *San Diego Air & Space Museum.*

aboard the PB4Y-1 had a chance to bail out, nor did the pilot of the FM-2 escape his aircraft. In just seconds, twelve navy air crewmen were dead amid the burning wreckage of their machines. The two aircraft lay only yards apart in an area of charred chaparral. The navy recovered all crew members from both wrecks and then proceeded to remove most of the aircraft wreckage, none of which had any salvage value. As time passed, the chaparral grew back, covering part of the remaining debris. In later years, Birch Hill was developed and became a gated community with a little-known history about a long-ago midair disaster.

Occasionally, test flights from aircraft factories around Lindbergh Field ended tragically too. One such loss occurred on October 13, 1944, when the chief test pilot for Ryan Aeronautical Company, Robert J. Kerlinger, was killed while flying the protoype XFR-1 Fireball. The XFR-1 offered the navy an innovative blend of both piston and jet propulsion systems in a single-seat fighter aircraft. The FR-1 could fly safely using just the 1,350-horsepower Wright radial engine or the 1,600-pound thrust General Electric J31 turbojet. Using both power plants at once allowed the XFR-1 to achieve a maximum speed of 404 miles per hour.

XFR-1 Bu No 48232 crashed during high-speed aerobatic flight tests. No definitive cause for the accident could be determined due to the complete destruction of aircraft when it plunged into Sycamore Canyon on Camp

Kearny. Kerlinger may have experienced pilot blackout due to the high G forces to which he was subjected during the assigned flight test regimen.

Test pilots were trained and paid to push new aircraft types to the limits, occasionally with fatal results. That was the case for another Fireball pilot who crashed near Camp Kearny during high-speed dive and recovery tests on March 26, 1945. Sadly, Ryan Company test pilot Maurice G. McGuire was killed. McGuire was flying a production FR-1 Bu No 39647 when he was unable to recover from a power dive; compressibility and possible pilot blackout were listed as factors in the official accident report. As a result of this tragic loss, modifications were made to the FR-1 that improved its handling characteristics. Making progress by improving overall aircraft designs sometimes comes at a high price paid for by test pilots so that others would be safer in operational environments.

Not all test flight losses were due to extreme testing regimens. One loss occurred during a routine pre-delivery test flight of a Consolidated Vultee PB4Y-2 Privateer. It departed Lindbergh Field on November 22, 1944, with a factory test crew of six men on board. Before the military would take delivery of a factory-fresh aircraft, it had to be flight tested. Since the PB4Y-2 was a four-engine patrol bomber for deployment by the navy, there were myriad systems to be exercised and fully checked out. The normal flight crew for the Privateer was eleven men, including gunners for six defensive twin .50-caliber gun turret positions, all of which had to be tested. A typical test flight could last five hours or more, with four test crew moving throughout the aircraft checking turrets and fasteners and looking for fuel or hydraulic leaks. This would not be the case with Bu No 59554, for just as it began to climb following a midday takeoff, the outer left wing separated from the aircraft, causing the PB4Y-2 to crash into a ravine in an area known as Loma Portal, killing all on board. The left outer wing section came down on a residence nearby without injuring anyone. The fact that no one on the ground was killed or injured was a miracle.

Wings just don't fall off new aircraft, and the accident investigation team included not just representatives from the builder and the navy but the FBI as well, for good reason. Sabotage was a possibility that reared its ugly head on numerous occasions during the Second World War in factories around the country. The cause of the accident was quickly resolved because the intact wing section showed that 98 of the 102 fasteners were missing. Two workers and two inspectors were fired, but no charges were filed. Thankfully, there were only a few cases of assembly error during WWII that caused loss

The Consolidated PB4Y-2 was just entering production when a routine factory test flight went tragically wrong on November 22, 1944, killing six airmen in a crash near Loma Portal. *San Diego Air & Space Museum.*

of life in spite of the fact that tens of thousands of aircraft were produced on a twenty-four/seven basis.

Today, Loma Portal is a fully developed community of private residences where ravines and gullies are still open space and grasses, plants and trees flourish. Some remnants of the PB4Y-2 are there also, and one property owner, aware of local history, quietly honors the memory of the flight test crew with a small memorial overlooking the crash site of Bu No 59554.

As 1944 drew to a close, losses of military aircraft continued to accrue across San Diego County, including those of two marine corps avengers near Lake Hodges. Grumman TBF-1C Bu No 24499 crashed on December 15, 1944—killing all four on board—while leading recovery vehicles to another Avenger crash site that occurred earlier that same day. The first loss was USMC, TBM-1, Bu No 24800, which shed its starboard wing during a practice run on a bombing target near Lake Hodges. All four crewmen aboard the TBM-1 were killed instantly. Both aircraft were assigned to VMTB-943 at Marine Corps Air Station El Toro in Orange County,

California. The loss of Bu No 24800 was attributed to stripped threads on bolts that secured wing lock fittings. The loss of Bu No 24499 was caused by an accelerated stall induced by a steep pull-up over the crash site of TBM-1. Eight marines were tragically killed in one day while engaged in routine, non-combat-related operations.

The year 1945 began with the knowledge that the Axis Powers were in retreat and that Germany might soon be defeated but that the war with Japan could take several years to be successfully resolved. The drumbeat of aircraft manufacturing, acquisition, training and deployment continued at an impressive pace, and surprisingly, the aircraft accident rate began to decline in San Diego County.

There were still losses that were weather related, during operational training regimens and in testing new aircraft designs also. Some accidents happened during routine flights that were transiting San Diego County airspace. One such loss was that of an army air force Vultee BT-13A, serial number 41-22019, flown by Second Lieutenant William Ernest Dryer. Lieutenant Dryer had departed Van Nuys AAF on March 14, 1945, shortly after 1:00 p.m. en route to Yuma, Arizona. There, he and his passenger,

On December 15, 1944, two marine Grumman Avengers crashed near Lake Hodges, killing four men in each aircraft. A midair collision was not the cause of this unusual double loss. *San Diego Air & Space Museum.*

Corporal Joseph F. Schubert, would spend the night before continuing on to Goodfellow Field in San Angelo, Texas.

Lieutenant Dryer received a weather briefing prior to his departure from Van Nuys, and his briefer stated that IFR conditions could be encountered in the mountains east of San Diego and that he should land at one of the airfields near San Diego. There he was directed to check the weather reports before continuing on to Arizona. Lieutenant Dryer was instrument rated and apparently decided not to stop but to continue on to Yuma, following the highway that is now Interstate 8 east of the San Diego area.

Unfortunately, BT-13A, 41-22019 crashed and burned just below the summit of cloud-enshrouded Los Pinos Mountain, killing both Lieutenant Dryer and Corporal Schubert. The BT-13A narrowly missed colliding with the US Forest Service lookout tower on the mountaintop. Had Lieutenant Dryer been two hundred feet higher or just a few hundred yards to the north or south of the summit, he would have been home free, flying into the clearing skies over the Colorado desert and going on to his next stop in Yuma, Arizona.

Members of the Dryer family visited Los Pinos Mountain in the first decade of the twenty-first century to honor the memory, service and sacrifice of Second Lieutenant William Ernest Dryer. Today, a micro site remains on Los Pinos Mountain where parts of the BT-13A can still be seen, including a parachute wrapper, Plexiglas, a position light lens and burned structural fragments.

Pilots followed roadways and highways in good weather, too, for a number of reasons. Roadways could be emergency landing strips, they provided an easy way to navigate on long cross-country flights and they provided a sense of security when flying over rugged or forbidding terrain.

Navy lieutenant John L. Wirth had departed Naval Air Station San Diego on April 13, 1945, en route to El Centro Naval Air Facility in Imperial County, California, when the engine of his General Motors FM-2 Wildcat, Bu No 56792, began to fail. Witnesses driving on Highway 80 (Interstate 8) thought the pilot was trying to land on the roadway. He failed to see power lines draped across his flight path, and when he flew through the lines, the right wing of his Wildcat fighter was sheared off. The Wildcat continued flying for about three hundred yards until it crashed into the side of a hill and burst into flames, instantly killing Lieutenant Wirth. Mechanical problems, not weather, were a factor in this loss of a man and his machine.

When an in-flight emergency occurs, the pilot has to evaluate his options and act quickly. If the aircraft is going down, he has to decide if there is

This Vultee BT-13 Valiant assigned to the army air force crashed on Los Pinos Mountain on March 14, 1945, with a fatal result for two crewmen. *Courtesy AAHS.*

enough altitude for a bailout or if a crash landing is the only option. The latter option was selected by navy lieutenant Edward D. Frazar during a practice dive-bombing run near Lower Otay Reservoir. Lieutenant Frazar did not have sufficient altitude to safely bail out, and the surrounding terrain was mountainous and boulder strewn, so he decided to ditch his Curtiss SB2C-4 Helldiver Bu No 19866 in the only nearby body of water, Lower Otay Reservoir.

The water landing was accomplished with aplomb, and the Helldiver stayed afloat long enough for the pilot and his gunner to safely escape and swim to shore. Lieutenant Frazar's gunner was army sergeant Joseph Metz, who had volunteered to go on the training flight. The date of the ditching was May 28, 1945, and while Germany had recently surrendered, the war with Japan still raged, allowing no letup in preparation for the battles yet to come in the Pacific Theater of Operations.

The author noted the loss of Bu No 19866 in several of his early books on aircraft accidents in California, but there seemed to be little interest in recovering the basically intact Helldiver until a fisherman noticed the shape of an aircraft on his fish finder in the winter of 2009. His discovery led to

an effort to recover the SB2C-4, and that was accomplished in 2010. Bu No 19866 is currently undergoing a restoration, made considerably easier by having been in a freshwater environment for sixty-five years. Eventually, the SB2C-4 will be displayed at the National Naval Aviation Museum in Pensacola, Florida.

The United States Coast Guard has had an aviation presence in San Diego County since 1934. Coast guard aircraft have provided a range of services, including security patrols and search and rescue missions. One of the many types of aircraft flown by the coast guard included the Grumman JRF-5G Goose, a twin-engine, high-wing amphibian that served as a light transport and on air-sea rescue operations.

All aircraft require routine maintenance, and following major overhauls, a test or check flight is usually made. On September 5, 1945, JRF-5G Goose, serial number 37795, departed Naval Air Station San Diego with Chief Aviation Pilot Glen D. Ferrin at the controls and Aviation Machinist Mate Frank S. Rakovic serving as flight engineer and observer. Ferrin had accrued two thousand flight hours during his two years of coast guard service and was credited with rescuing fifteen army, navy and marine pilots and aircrew. Tragically, as he flew down Mission Gorge toward San Diego on a checkout flight, he collided with high tension lines and crashed near the bottom of Mission Gorge. There was no post-impact fire, but both CAP Ferrin and AMM Rakovic were killed on impact. In those bygone years, power lines draped across canyons lacked the high visibility reflectors that are used today.

After World War II ended, the number of military flights began to diminish somewhat. However, the return to peacetime did not preclude the need for a strong and well-equipped military. As dozens of army, navy and marine squadrons stood down, and as thousands of WWII-era aircraft were flown to disposition centers for storage or salvage, routine training and readiness activities continued unabated.

Naval aircraft often flew simulated attack missions on navy vessels operating in the waters west of San Diego. These missions allowed ship-based crews to practice antiaircraft drills and maneuvers. The Martin JM-1 was one of the most common types used in the early postwar years. In army service during WWII, it was known as the B-26 Marauder, a fast and effective medium bomber. In navy and marine service, it was assigned to utility squadrons, stripped of its armament and painted high visibility yellow. Equipment was added to allow fighter pilots to practice firing live ammunition at a target sleeve towed behind the JM-1.

Utility Squadron 12 was based at NAS San Diego, where it conducted target towing missions over the Pacific Ocean, San Diego and Imperial Counties. Martin JM-1 Bu No 66695 departed its base at 10:00 a.m. on November 8, 1945, to assist the crew of navy destroyer DD-760, the USS *Thomason*, in practicing antiaircraft tracking for the ship's gun crews. At 10:30 a.m., Bu No 66695 was observed crashing into the ocean and exploding, killing all six crewmen. The cause of the accident was assigned to the pilot, who dove in low but misjudged his altitude. Floating debris was observed, but no bodies were recovered, and the entire crew was posted missing at sea.

The end of the Second World War had an immediate impact on civilian aviation in the United States. There were thousands of trained pilots leaving the military who wanted to continue flying. Companies like Cessna, Beechcraft and Piper began offering aircraft for sale to meet the growing needs of the civilian aviation market. From late 1945 to 1948, one of the cheapest ways to obtain an aircraft was to purchase a surplus military trainer, light transport or even a retired fighter plane. The cost for an air-worthy war surplus plane could be as low as $500, or for a few thousand dollars, a large cargo aircraft could be purchased.

The Cessna Model T-50, a five-seat twin-engine light transport, was very popular and easy to maintain. In military service, the T-50 was known as the AT-17, UC-78 or JRC. The popular name assigned to the type was Bobcat, but most pilots called it the Bamboo Bomber because of its wood and fabric construction. The Bobcat was made famous in the 1950s television series *Sky King*.

Five men departed El Paso, Texas, on December 21 en route to San Diego, California. They were flying in Cessna T-50 Bobcat NC-44000, owned by a La Jolla resident. At 10:30 p.m., the pilot of the T-50 radioed Lindbergh Field tower to say that he was low on fuel and lost in a rainstorm that was pummeling western San Diego County.

When the T-50 failed to arrive as expected, a search effort was launched, but bad weather initially limited the aerial search flights as more than three inches of rainfall drenched the San Diego area. When the weather did improve, search planes covered thousands of square miles, including San Clemente Island and parts of northern Mexico, without result. Finally, on December 28, wreckage of an aircraft was spotted in the Laguna Mountains, but when ground teams arrived at the crash site, they found a twin-engine aircraft with one body on board: that of Lieutenant George G. Redmon, who disappeared on February 28, 1944, while flying Lockheed P-38H 42-

66695. The search for one missing aircraft had yielded another, and with it closure for the Redmon family.

Searchers did not give up on locating the missing Cessna T-50, and on January 1, 1946, they found it. The crash site was not in the high mountains, on San Clemente Island or on the Pacific Ocean but on a barren hillside near Lake Hodges. The mostly wood- and fabric-covered plane had burst into flames on impact, burning the bodies of all on board beyond recognition. The missing Cessna had been on an air taxi flight at the time of the accident, chartered by four men whose airliner had been grounded in Texas. A winter storm sweeping into Southern California had been a factor in an accident that killed two army, two navy and two civilians.

CHAPTER 3
SKY'S THE LIMIT!

The end of the Second World War heralded a new age in aviation for San Diego County. Not only was the United States of America the most powerful nation militarily, but it was the hands-down leader in the world of technology. The Southern California aviation industry was on the cutting edge of new military and commercial aircraft designs and manufacturing. At Convair, new airliner production to meet the increasing demand for comfortable and faster aircraft was ramping up. Convair also introduced new military designs, including the world's first intercontinental bomber, the B-36 Peacemaker. Also increasing was production of inexpensive and versatile light aircraft for the postwar public that included thousands of former service men and women who wanted to continue flying for recreational or business purposes.

Commercial air carriers began expanding routes, and the public started flying on airliners in unprecedented numbers. Lindbergh Field, near downtown San Diego, became an important hub, with flights arriving and departing for destinations throughout the United States and Mexico. Also, the military presence in the county experienced growth, as Naval Air Station San Diego became NAS North Island, where both land- and sea-based aircraft squadrons were assigned. NAS Miramar became a key navy West Coast fighter base when early jet operations began in the late 1940s. The coast guard continued to maintain an important presence at Lindbergh Field. Marine aviation was located at Camp Joseph H. Pendleton until NAS Miramar became a marine corps air station in 1999.

Brown Field remained active in the postwar years as a naval auxiliary airbase hosting the utility squadrons VU-3 and VU-7. In 1962, Brown Field became a municipal airport. Gillespie Field transitioned to a civilian airport in 1946, and Montgomery Field provided the San Diego area with another busy postwar airport to accommodate the growing numbers of privately owned aircraft. At that time, San Diego County was home to more than thirty military and civilian airports and landing strips. Today, more than twenty still remain operational, including Naval Outlying Field Imperial Beach, known as the "Helicopter Capital of the World."

In 1946, weather permitting, flying across the country could take several days. Such was true for American Airlines Flight Number 6-103, which departed New York City at 9:02 a.m. on March 2, 1946, en route to San Diego. Stops included Nashville, Tennessee; El Paso, Texas; and Tucson, Arizona, from where its final leg into San Diego would be flown.

American Airlines Douglas DC-3 NC-231799, Flagship Baltimore, departed Tucson at 5:59 a.m. with an estimated arrival in San Diego at 8:30 a.m. on March 3, 1946. At 8:12 a.m., Airway Traffic Control attempted to contact Flight 6-103, and when no response was received, an alert was issued and a search was initiated. At 1:05 p.m., the crew of a coast guard Martin Mariner search aircraft spotted the smoldering wreckage of Flight 6-103 on Thing Mountain, about fifty air miles east of San Diego. The first ground recovery teams arriving at the crash site struggled through dense brush and intermittent heavy rain and hail. What they found at the crash site was a ghastly scene of burned and dismembered bodies. Only six victims were recognizable. Numerous watches found in the wreckage had stopped at 8:12 a.m., fixing the time of the impact. Twenty-seven passengers and crew, including two infants, were killed, making this the worst air disaster in the county's history. Among those killed were six members of the military and two individuals who had just completed their service. One was a B-24 bomber pilot who had flown thirty-seven combat missions in the South Pacific, and Miss Gladys De Lancey had served in the WAVES.

First responders declared the crash of Flight 6-103 a non-survival event. It was noted that the left wing had struck the terrain first, causing the aircraft to whip to the left, tearing off the right wing in the process. As the fuselage came to rest, it was consumed by fire. With the help of county, state and military personnel, all bodies were recovered on March 4. That night, snow fell on the mountains of eastern San Diego County, and the next morning, the In-Ko-Pah and Laguna Mountains, including the wreckage of DC-3, were covered in a mantle of white.

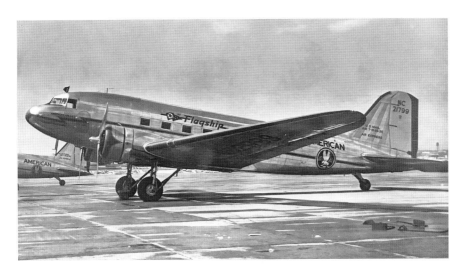

American Airlines Douglas DC-3 NC-21799, Flagship Baltimore, crashed on March 3, 1946, on Thing Mountain, killing twenty-seven passengers and crew. *David Lane Collection.*

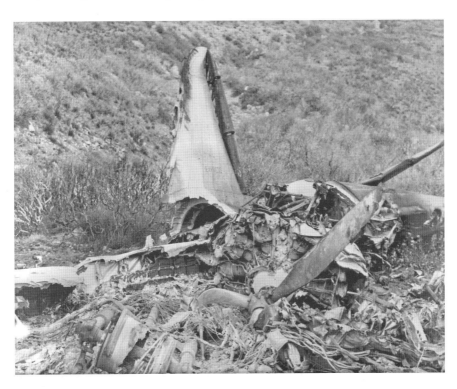

A grim scene at the American Airlines DC-3 crash site on Thing Mountain in eastern San Diego County. *G.P. Macha Collection.*

Investigators from the Civil Aeronautics Board made several trips to the crash site of Flight 6-103 and determined that the crash had not been caused by mechanical problems but by a pilot who had deviated from the assigned airway and altitude, descending into dense clouds and strong turbulence. It has been conjectured that the pilot in command thought he was closer to San Diego than he actually was and had started his descent too soon. The accident site was located at about five thousand feet, well below the crest of the six-thousand-foot Thing Mountain ridge into which the ill-fated airliner had crashed. Even if the DC-3 had cleared Thing Mountain, it was still too low to safely fly over the six-thousand-foot Laguna Mountains to reach Lindbergh Field.

In the years that followed this accident, most of the salvageable aluminum was smelted and sold for scrap value. The chaparral grew back, covering the debris field, and the remains of NC-21799 was forgotten until a retired airline captain made it his mission to find the crash site. Working with the author and Larry Thompson, a member of the Manzanita tribe, David Lane made numerous forays into the rugged mountains where the DC-3 was supposed to have crashed. On a hot day in September 2015, he first located the spot where the aluminum had been salvaged and then proceeded to locate the main impact. As an airline pilot, Lane wanted to understand what had happened that caused Flight 6-103 to have been so low and three miles north of the VFR flight path. Additionally, Flight 6-103 was many more miles north of the IFR Red Airway 9 flight route, used in periods of bad weather.

On November 14, 2015, the author, David Lane, Larry Thompson and other members of the Project Remembrance Team hiked to the crash site of Flight 6-103 to pay their respects to the twenty-seven passengers and crew who had lost their lives on March 3, 1946, aboard the Flagship Baltimore. A notable artifact was found at the impact site: a pepper shaker with the American Airlines engraving.

Mary Sellers Gallagher is a longtime resident of Southern California and no stranger to accidents involving aircraft. As a young girl, she witnessed the navy airship USS *Akron* at Kearny Mesa as it attempted to land without a mooring tower. Groups of navy enlisted ranks were attempting hold on to mooring lines dropped by the *Akron* when the airship suddenly began to rise, carrying four sailors aloft. One man dropped off a line, breaking his arm, but three others hung on as best they could. Two of those men later fell to their deaths from hundreds of feet above the ground. Amazingly, one man managed to hang on for more than an hour before he was pulled inside the huge dirigible and saved.

As a young woman during WWII, Mary met and fell in love with a navy aviation machinist mate who had served aboard the famed aircraft carrier USS *Hornet* (CV-8) in four raids and three major battles: Midway, Coral Sea and Santa Cruz. His name was Charles Sellers, and he flew dozens of combat missions from the deck of the *Hornet* in the Grumman TBF-1 Avenger torpedo bomber serving as the radio operator and gunner. He returned to San Diego in 1944, married in 1945 and started a family in 1946.

Mary Sellers was a San Diego native, and she enjoyed her life there, as did her husband, who was assigned to Headquarters Squadron 14 at Naval Air Station San Diego. Aviation Machinist Mate Third Class Charles E. Sellers was twenty-three years old and flying regularly as a crewman on the Beechcraft SNB/JRB twin-engine six-passenger light transport aircraft.

Aviation Machinist Mate Third Class Charles Sellars survived combat in the Pacific during WWII but died tragically in the crash of a navy Beechcraft JRB-4 on April 19, 1946, at Camp Pendleton. *Courtesy of Mary Sellars Gallagher.*

On the evening of April 19, 1946, Naval Aviation Pilot Rulon J. Skeen and AMM Third Class Charles E. Sellers departed NAS San Diego and flew to Mines Field (now LAX) to deliver a passenger. Sellers had been asked that afternoon to substitute for another airman whose wife had been hospitalized.

On the return flight to San Diego, NAP Skeen, the pilot of Beechcraft JRB-4 Bu No 76779, reported that his engines were running rough and that he was going to attempt a landing at Camp Joseph H. Pendleton. NAP Skeen was paralleling Highway 101 (now I-5) as his Beechcraft JRB-4 continued to lose altitude, forcing the pilot to make an immediate emergency landing with his wheels and flaps up. Unfortunately, the terrain over which the aircraft was flying was brushy, hilly and rough. NAP Skeen elected to crash-land in a small ravine after cutting the switches to minimize the possibility of a post-impact fire. The touchdown speed of the JRB-4 was about ninety miles per hour. It cut a swath through the brush as it bounced and came to a sudden stop. Tragically, AAM Third Class Charles E. Sellers, riding in the cockpit's right seat, was instantly killed. NAP Rulon J. Skeen, in the left seat,

sustained only minor injuries. In a state of shock, NAP Skeen walked to the nearby Coast Highway and flagged down a motorist who drove him into San Clemente.

Mrs. Sellers was notified the following morning that her beloved husband had been killed the night before while flying back to San Diego. In a 2015 telephone interview, Mary Sellers Gallagher said her husband had called her to say he was assigned to fly and that he would not be home that night. Mary said she went to bed at the usual time but woke herself up screaming her husband's name. Though startled, she was able to go back to sleep since there was no nightmare associated with the event. A knock on her door the next morning brought the sad news that her husband had been killed in a plane crash. In retrospect, she realized what her crying out might have meant. Shortly thereafter, Sellers experienced a miscarriage during the fourth month of her pregnancy. Sorrow and depression understandably followed the deaths of her husband and unborn child.

Mary Sellers wanted to know what had happened to cause her husband's plane to crash. To that end, Rulon J. Skeen visited Mary several weeks after the accident. Expressing his condolences, he told her that her husband had remained calm during the emergency, telling him to "cut the switches to prevent fire." Mary Sellers married again, raised a family and enjoyed a long career as a high school math teacher. In August 2011, she contacted the author for assistance in obtaining the accident report for JRB-4 Bu No 76779. The report provided additional information that helped Mary find closure for a loss suffered so long ago.

As 1946 drew to a close, another airliner loss occurred, that of Western Airlines DC-3 NC-45395 with twelve crew and passengers on board. It was Christmas Eve afternoon when Flight 44 departed Los Angeles Airport (Mines Field) en route to Holtville in Imperial County. On the return flight to Los Angeles, Flight 44 was scheduled to stop at Lindbergh Field in San Diego and Dougherty Field in Long Beach. The departure from Holtville at 6:50 p.m. was uneventful, but twenty-eight minutes later, radio contact with NC-45395 was lost. A short time later, Flight 44 was posted overdue by the Lindbergh Field tower. Search efforts began in earnest on Christmas morning, though they were hindered by the effects of a lingering cold front that brought rain and snow to the Laguna Mountains, grounding all search aircraft. The dense fog and clouds enshrouding the mountains and passes of eastern San Diego County did not stop ground teams from making progress. On December 27, 1946, the crash site of Flight 44 was finally located less than one hundred feet below the crest of a mountain

ridge. High winds and snow flurries had impeded the discovery of the wreck until a lull in the storm gave an independent search team the break it needed. Through swirling mists, the searchers spotted the burned tail of the DC-3 on a brush-covered mountainside.

As the team members approached the crash site, they quickly realized that there would be no one to rescue. Before the storm closed in again, the team was able to locate ten bodies. As they withdrew, they radioed the authorities that they had found the wreck of Western Airlines Flight 44. The DC-3 crash site was located just below a six-thousand-foot ridge in an area of massive boulders and rock slabs. It was only three and a half miles northwest of the American Airlines DC-3 crash site.

The difficult task of removing bodies from the crash site was accomplished on December 28 by a contingent of twenty-five marines, accompanied by the San Diego County deputy coroner. During the recovery effort, a diamond ring valued at $10,000 was found. All personal effects, including the ring, were returned to the next of kin.

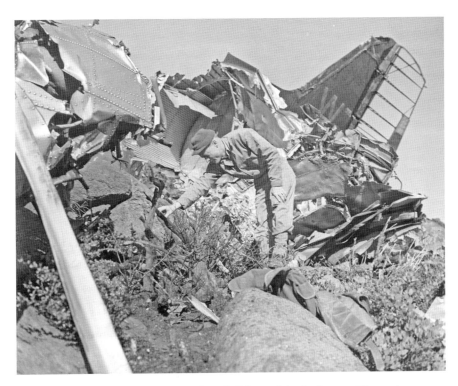

The December 24, 1946 Western Airlines DC-3 wreck in the Laguna Mountains. *Courtesy AAIR.*

The Civil Aeronautics Board determined that the cause of the accident was due to a combination of factors, including weather, darkness and failure of the pilot to make use of the Mount Laguna radio beacon to establish a position fix. The pilot, sadly, was not where he thought he was. Had Flight 44 flown the assigned Red Airway 9 route from Tucson to San Diego, this accident would probably not have occurred. In 1946, airliners did not have on-board radar available, nor did air traffic controllers have the technologies available that we take for granted in the modern era of air transportation.

As years pass, accidents can be forgotten, but they can become imbedded in family histories too. Some next of kin born after the accident happened want to know when, why and where the crash occurred. That was the case for Olivia Taylor, whose aunt, Adeline Jones, had been a passenger on Flight 44. Taylor learned from her father that her aunt Adeline was originally planning to take a bus from Holtville to San Diego to attend a family Christmas party. However, another member of Jones's family intervened and purchased an airline ticket so that Adeline could enjoy her first airplane ride and arrive earlier for Christmas.

In March 2015, the Project Remembrance Team was able to visit the Western Airlines DC-3 crash site thanks to the cooperation of representatives of the Ewiiaapaayp Band of Kumeyaay Native Americans, on whose land the wreck site is located. San Diego County resident Olivia Taylor was able to make the hike as well. Taylor's mission was to pay her respects to the memory of her aunt and to all those who lost their lives on the night of December 24, 1946.

Aluminum salvagers have reduced the DC-3 wreck to a large micro site. Nevertheless, engine parts, landing gear assemblies, aluminum wing and tail ribs, along with castings and fittings associated with flight controls and hydraulic lines, still remain. The chaparral is slowly reclaiming the crash site following the disastrous cedar fire of 2003. Many years ago, the Civil Air Patrol painted yellow Xs on two huge flat

Adeline Jones was only nineteen when she boarded Western Airlines Flight 44 at Holtville, California, on December 24, 1946. *Courtesy Olivia Taylor.*

rocks located in the center of the impact zone to prevent pilots flying nearby from reporting wreckage as that of a new crash site. These Xs are still visible today from the air and on Google Earth.

The Vought F4U Corsair was one of the finest navy and marine fighter-bomber aircraft of the Second World War and continued to be into the 1950s, as more advanced variants were produced. The F4U-4 was powered by a 2,100-horsepower, Pratt & Whitney R-2800 engine that enabled this version of the Corsair to achieve almost 450 miles per hour in level flight. Armed with six .50-caliber guns and able to carry more than two thousand pounds of bombs and rockets, it was a formidable carrier or land-based strike aircraft.

Drifting off the assigned flight path while flying in clouds or darkness can lead to accidents, but even those flying on the beam can come to grief if the altimeter is not carefully monitored.

On February 26, 1947, F4U-4 Bu No 81140, assigned to navy squadron VRF-1, was being ferried to NAS San Diego via Tucson, Arizona, by a young ensign. He collided with a cloud-covered ridge on the north flank of 4,167-foot Chiquito Peak. Death was instantaneous for the pilot as his Corsair came apart, catapulting the R-2800 engine more than four hundred yards beyond where the cockpit came to rest. The author visited the crash site in the Cleveland National Forest in March 2007. There was almost no fire damage, but a widely scattered debris field spanned nearly half a mile. If the pilot had been 100 feet higher, he would have flown out of the clouds over El Cajon with an unhindered view of his destination.

Military aircraft accidents in San Diego County increased during the early 1950s as training activities associated with the Korean War built up. The civilian accident rate increased as more private aircraft were sold. Civilian aviation enjoyed a heyday thanks in part to low fuel prices and low operating and maintenance costs. Some transport aircraft were used to carry cargo, including fresh produce, livestock and fish.

The United Mexican States became an increasingly important supplier of fresh produce and fish during the 1950s. The most efficient way to transport perishable commodities such as fruits and vegetables is by air transport. Aerovias Contreras, S.A., operated two war surplus Curtiss C-46F Commando transport aircraft flying on a non-scheduled basis from La Paz in Baja California, Del Sur to San Diego. San Diego Sky Freight employed the C-46F pilots, but the aircraft was licensed and maintained in Mexico. It had operated safely for six years when tragedy struck on the night of March 30, 1952.

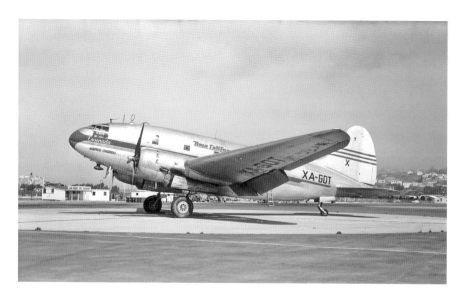

Curtiss C-46A cargo aircraft, registered in Mexico as XA-GOT, crashed in bad weather on March 30, 1952, near the international border in San Diego County. *William T. Larkins Collection.*

The C-46F that was involved in the accident was registered in Mexico as XA-GOT; aircraft registered in the United States at the time used NC (November Charlie), and by the early 1950s, N or November had become the standard. XA-GOT had departed La Paz with a load of fresh produce valued at $4,000 for delivery to Lindbergh Field in San Diego. When the C-46F failed to arrive, a search was initiated involving Mexican military and civilian aircraft south of the US-Mexico border. Five US Coast Guard aircraft, including two helicopters, flew over San Diego County.

On March 31, 1952, a coast guard PBY-5A Catalina amphibian spotted the wreckage of the missing C-46F near 3,566-foot Otay Mountain just north of the Mexican border. A coast guard Sikorsky HO4S helicopter landed near the wreck of XA-GOT and determined that both crewmen were deceased. The following day, a ground crew, supported by a coast guard helicopter, recovered the bodies of C-46F pilot Andrew J. O'Neal and his copilot, Adalberto Guerena. Members of the recovery crew described the broken-up and burned wreckage of the cargo plane as strewn with tomatoes, string beans and eggplant. While the terrain at the crash site is very rugged, that did not stop aluminum salvagers, who used burros and a portable smelter to reduce the wreckage, leaving only the unusable engines, landing gear and other assorted stainless steel parts at the crash site.

Darkness and stratus clouds were thought to be factors in the loss of XA-GOT and its crew. The area around Otay Mountain would see more aircraft accidents in the years that followed in conditions similar to those that claimed the C-46F on March 30, 1952.

The hamlet of Warner Springs is a San Diego County treasure bisected by State Highway 79 and located east of Lake Henshaw. For generations, hikers, fishermen and hunters have enjoyed the quiet beauty of this area. Warner Springs also attracts golfers and visitors to the hot springs, and those interested in flying sailplanes could do so from the nearby airfield and glider port.

Since before the Second World War, the Warner Springs area has been the scene of extensive training flights by air force, navy and marine aircraft. Sometimes residents witnessed formation flyovers or high-speed low-level flybys. Occasionally, there were mishaps, forced landings, bailouts and collisions with the surrounding mountains. Two unrelated crashes occurred in the winter and early spring of 1955 that claimed the lives of four navy men.

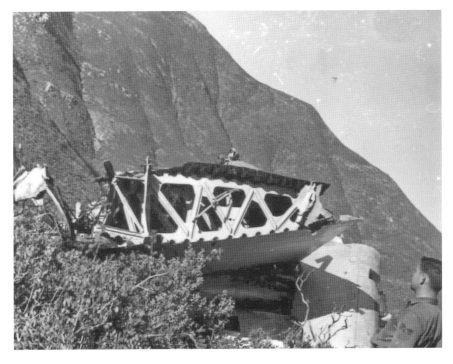

The wing structure of C-46A, XA-GOT, in rugged mountains just north of the Mexican border. *G.P. Macha Collection.*

On January 28, 1955, a Grumman F9F-5 Bu No 125595 assigned to VA-52 based at NAS Miramar crashed northeast of Warner Springs, killing the pilot. The crash touched off a brush fire that was quickly contained. The following day, a recovery team reached the crash site of the Korean War–era jet to recover the body of the pilot. As a coast guard helicopter attempted to land near the wreckage of the F9F-5, one of the rotor blades hit the ground, broke off and struck a navy member of the recovery team. Sadly, the aviation ordnance man first class died en route to the hospital.

The navy recovered the damaged helicopter and most of the Panther wreckage. The accident report stated that Bu No 125595 had been participating in simulated close air support activities with ground units when the crash occurred. In April 2011, the author visited the crash site and found parts of the F9F-5 scattered over three hundred yards of mountainous terrain. Some of the aircraft skin still had the midnight blue paint common on most navy and marine aircraft of that period. However, in 1956, the official navy paint changed to a light gray on the upper surfaces of the aircraft, with a white paint applied to the undersides.

On June 3, 1955, two navy ensigns departed NAS Miramar in a venerable North American Aviation SNJ-4 Bu No 10078 on a routine proficiency flight. The SNJ-4 was assigned to Fleet Air Reserve Squadron 12, and the pilots were assigned to VF-113. While there were no eyewitnesses to what happened, the SNJ-4 apparently flew over the January 28 F9F-5 crash site and then stalled, became inverted, crashed and burned about one-quarter mile northeast of the F9F-5 main impact. Authorities were alerted to the crash location by the post-impact fire. The investigation that followed stated that the SNJ-4 pilot may not have been familiar with mountain flying techniques, in which density altitude would be an important factor. As an aircraft slows while flying up a canyon, the air becomes less dense and sustains less lift, which can lead to a stall, with tragic consequences. Today, the burned remains of the SNJ-4 are overgrown by chaparral, but the inverted fuselage tubular structure can still be seen off the Pacific Crest Trail, a sad reminder of a sad day more than sixty years ago.

By the mid-1950s, the roar of jet engines became commonplace in the skies over San Diego County, and with those impressive sounds came jet accidents. On September 8, 1956, an air force pilot was forced to eject from his Lockheed T-33A jet trainer at twenty thousand feet due to an in-flight explosion. After safely ejecting, Captain Charles M. Sargen landed close to a brush and timber fire caused by his crashed T-33A. For the next several hours, Captain Sargen had to outrun the fast-moving flames before being

The North American SNJ-4 crash site above the Pacific Crest Trail, in which two navy aviators perished on June 3, 1955. *US Navy Official via Bert Bertels.*

rescued by a coast guard helicopter. The remains of the T-33A T-Bird, serial number 51-9226, still litter a rugged area near Pine Mountain, seventeen miles north of the town of Ramona.

The navy introduced the McDonnell F3H Demon series of jet fighter aircraft into operational service in 1956, but the design was initially plagued by problems with the Westinghouse J-40 turbojet engine. However, once the Allison J-71 replaced the J-40, the service record of the Demon quickly improved. The F3H became one of the first swept-wing jet aircraft to operate from aircraft carriers, serving from 1956 to 1963 with navy fighter squadrons. The Demon was an interim subsonic fighter and was replaced in the early 1960s by jets that could exceed the speed of sound, such as the Vought F-8 Crusader and the McDonnell F-4 Phantom.

While the F3H remained in operational service, it enjoyed a relatively good safety record, but there were accidents. Almost a dozen were lost during operations in San Diego County. In recent years, the author has visited four

Demon crash sites in San Diego County. One of the most interesting is that of F3H-2N Bu No 133607, assigned as an all-weather, day or night fighter to navy squadron VF-124. These "Moonshiners" were based at Naval Air Station Miramar.

In 2006, the author was contacted by a lifelong San Diego resident, Dennis Richardson, about an aircraft wreck on a mountainside near his home in Lakeside. Thanks to Richardson, the author and his son were able to hike to the wreckage of what turned out to be a McDonnell F3H-2N. The identification of the type was confirmed by aircraft parts with the prefix numbers 25- and a partially intact wing with the swept shape characteristic of the fabled Demon fighter jet.

Finding the history of the accident and the fate of the pilot took considerable time, but the author eventually learned that the pilot had ejected safely on the night of October 4, 1956, while lining up to land at Miramar. The reason for the ejection was a faulty cockpit instrument and vertigo induced by clouds and darkness. The pilot's name was Lieutenant Junior Grade Ralph "Skeeter" Carson. Richardson located Carson in 2008, happily retired in Florida, and invited him to come back to San Diego County to visit his crash site. Carson agreed and journeyed west with two VF-124 squadron mates.

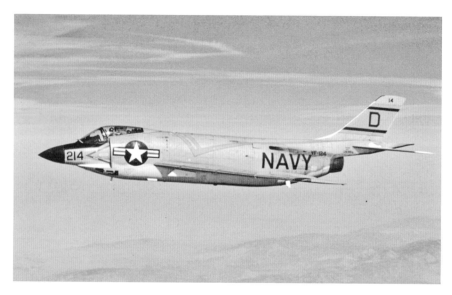

A McDonnell F3H-2N Demon similar to that flown by Lieutenant (jg) Ralph Carson, October 3, 1956. *US Navy Official via Dennis Zager.*

On July 8, 2008, Dennis Richardson led members of the Project Remembrance Team, including the author, to a property where the wreckage of Bu No 133607 could be easily seen. The Demon was still plastered on a ridgeline, largely undisturbed since 1956. From our vantage point across from the crash site, the group was taken to a ranchita, from which everyone hiked to the Demon site. The group was able to see both wings, part of the tail assembly, landing gear and the still-recognizable Allison J-71 turbojet engine that once powered the F3H-2N.

It had been fifty-two years since the accident, and Ralph Carson shared his story about flying in instrument conditions aggravated by turbulence, compounded by vertigo. Carson described his successful ejection, followed by a hard landing on rocky ground. Unable to see anything, he wisely stayed put, using his life raft to provide a primitive shelter. When the morning light finally came, he found that he was sitting on a cliff edge west of 3,648-foot El Cajon Mountain. As the morning clouds and fog dissipated, a search helicopter dispatched from NAS North Island spotted his flare signal. Carson said he was cold, shaken and hungry when he was rescued from his cliff-side perch. It was only then, as the helicopter carried him off the mountain, that he realized how close he had come to falling to his death.

Because Lieutenant (jg) Carson had been posted missing, the navy had sent a VF-124 squadron mate, Lieutenant Wally Schira, to provide company and encouragement for Ralph's distraught wife. Lieutenant Schira was with Mrs. Carson when she received the phone call about 9:00 a.m. on the morning of October 5 that her husband was safe and that he had sustained only minor injuries.

Ralph "Skeeter" Carson was a Naval Academy graduate who served his country for twenty-six years, retiring as a US Navy commander. Sadly, he passed away in November 2014 at the age of eighty-five. He is respectfully remembered by the author as an officer and gentleman and one of VF-124's gallant "Demon Drivers."

Ralph Carson was not the only pilot to return to the crash site of his jet. In early February 2015, former navy pilot Robert Jones was able to visit the remains of his North American Aviation FJ-4B Fury jet fighter, Bu No 143525, which had crashed on November 5, 1957. Engine failure forced Jones to eject, and his aircraft came down on a privately owned ranch in the mountains west of Lake Henshaw. Thanks to the efforts of the property owners and a helicopter ride provided by the marines, Jones was able to see the sizeable wreckage of his Fury jet fighter that was assigned to attack squadron VA-146 based at NAS Miramar. Carson and

The author and his son, Pat J. Macha, at the crash site of F3H-2N, flown by Lieutenant (jg) Ralph Carson. *Photo by Tom Maloney.*

Jones were able to eject successfully from their stricken aircraft, but this is not always the case.

March Air Force Base, established in 1918, is located in Riverside County, California, and is still an operational base today. From 1949 to 1982, March was a Strategic Air Command base. It was home to the Boeing B-47 Stratojet and Boeing B-52 Stratofortress intercontinental jet bombers. The Stratojet was the first operational swept-wing jet bomber deployed by the air force. Boeing built more than one thousand of these sleek six-engine aircraft that served from 1953 to 1969.

On December 18, 1957, a TB-47B, serial number 50-076, assigned to the 443rd Bomb Squadron, was engaged in a routine training flight with a crew of three on board. Number 50-076 was assigned for training use only, hence the TB designation.

Number 50-076, call sign Texas 66, departed March AFB at 11:08 a.m. and, after an uneventful training mission, began its landing descent into March AFB at about 1:45 p.m. At 2:00 p.m., the TB-47B was no longer visible on the March AFB radar, causing alarm. Less than four minutes

later, 50-076 crashed into cloud-enshrouded 6,142-foot Mount Palomar, killing all three crewmen instantly. Exploding debris from the TB-47B narrowly missed the telescope complex, but the forty-eight-inch Schmidt Telescope dome was hit by pieces of wreckage, and many windows were broken. The two-hundred-inch Hale Telescope was about four hundred yards from the main impact of the bomber, and a brush fire started by the crash was quickly contained.

Visibility on Mount Palomar at the time of the crash was described as zero/zero, and the weather was cited as one of several factors in the loss of the Stratojet and its crew. Most of the wreckage was promptly removed, and the few parts remaining are now overgrown by vegetation. There is no memorial marker at or near the crash site honoring these three air force officers who lost their lives while in the line of duty.

The navy flew the ubiquitous Lockheed T-33A as an advanced trainer, but in navy service, the designation was TV-2. Several of these aircraft crashed in San Diego County, including one assigned to VF-121 at NAS North Island.

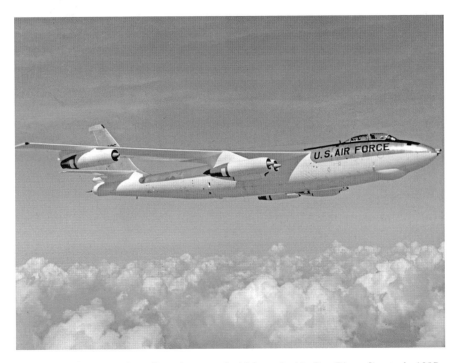

A US Air Force Boeing B-47 Stratojet, two of which crashed in San Diego County in 1957 and 1961. *San Diego Air & Space Museum.*

TB-47B 50-076 that crashed near Palomar Observatory on December 19, 1957, killing three air force officers. *G.P. Macha Collection.*

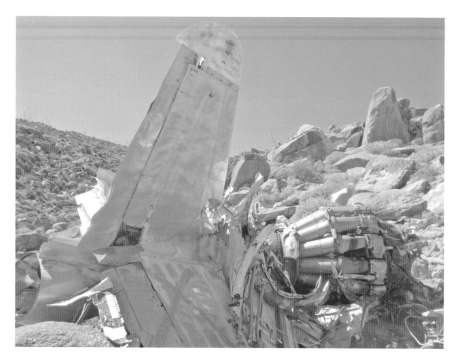

The tail section of a Lockheed TV-2 navy jet trainer, from which both navy crewmen ejected safely on September 22, 1958. *Photo by David Lane.*

On September 22, 1958, TV-2 Bu No 136834, call sign Cherry Coke 185, was on an instrument training flight with a crew of two. The first hour and a half proceeded normally until the Westinghouse J-33 turbojet engine malfunctioned, forcing both pilots to eject at ten thousand feet over Anza Borrego State Park. Prior to departing the rapidly descending TV-2, the instructor pilot sent a distress message to NAS North Island advising them of his approximate location. Within thirty minutes, a navy helicopter rescued the pilots, neither of whom had suffered any serious injury. Smoke rising from the crash site had helped guide the helicopter pilot to an area near the burning wreckage.

The TV-2 had come down in a rugged boulder-strewn landscape southwest of Agua Caliente Springs. The empennage, tail assembly and outer wing tanks had somehow remained intact, undamaged by the crash and post-impact fire. In 2009, Ramona resident Jamie Lievers located the crash site, and in March 2011, he led members of the Project Remembrance Team, including noted author Eric Blehm, to the remains of the Lockheed TV-2. The compressor section of the long-silent J-33 engine was found to be remarkably intact. Many other interesting items were observed, such as the cockpit wind screen, landing gear assemblies, exterior fuselage and wing parts with the white and orange paint scheme used on navy training aircraft.

The TV-2 crash site looks much as it did in 1958, protected by the mountainous desert terrain, climate and most recently by the Federal Antiquities Act, which extends legal protections for artifacts fifty years and older. Lockheed built more than 6,500 T-33/TV-2 aircraft, but relatively few remain in existence today. Sometimes this means that crash sites can provide our last links to halcyon aircraft of the past, such as the beloved T-Bird.

In the twenty-first century, aircraft known as flying boats are rare, but in the first half of the twentieth century, flying boats, float planes and amphibians were in widespread use, primarily by the navy and coast guard, although the air force also used some amphibians for search and rescue work.

The last flying boat in US military service was the Martin Marlin, a descendent of the famed WWII-era Martin Mariner. The P5M-2 Marlin was a large twin-engine aircraft designed to accomplish a number of vital navy missions, including antisubmarine warfare, reconnaissance and air-sea rescue. The Marlin served during the early phases of the Vietnam War, flying patrol missions off the coast of South Vietnam until the last Marlin squadron was retired in 1967, ending the operational role of the flying boat with the navy.

Until 1967, North Island was home to several Marlin-equipped squadrons, including Patrol Squadron VP-48. The beaching ramps can still be seen today, reminders of a bygone era in naval aviation. Most accidents associated with the Marlin involved open ocean landings and takeoffs when sea conditions were rough.

The loss of P5M-2 Bu No 135483, assigned to VP-48, was unusual in that it occurred over the Laguna Mountains of San Diego County on January 1, 1959. The crew of Bu No 135483 was tasked that day with a combat proficiency training mission near the navy seaplane base at the Salton Sea in nearby Imperial County. The Salton Sea provided Marlin crews with a place where they could practice landings, takeoffs and ordnance delivery techniques on water and land-based targets as well.

The takeoff of Bu No 135483 was made at 3:07 p.m. from NAS North Island sea plane base with a crew of three officers and seven enlisted ranks. As the Marlin flying boat headed east, the pilot, Lieutenant (jg) John G. Collier, climbed to seven thousand feet in order to safely clear the Laguna Mountains. At takeoff, the P5M-2 weighed 72,167 pounds, including 1,850 pounds of internal ordnance and 16,800 pounds of fuel.

As the flying boat approached Descanso, a small community nestled in the Laguna Mountains just north of Interstate 8, an oil leak was detected in the Marlin's right engine. Almost immediately, an uncontrolled fire

A Martin Marlin P5M-2 navy flying boat similar to Bu No 135483, which crashed in the Laguna Mountains on January 1, 1959. *San Diego Air & Space Museum.*

Navy Patrol Squadron VP-48 squadron patch. VP-48 was based at NAS San Diego. *Courtesy Lee Anderson and www.VP48.org.*

enveloped the massive Wright 3350-32 radial engine. Losing both power and altitude, the pilot rang the bailout bell, and the crew scrambled to put on their parachutes and jump. At this time, the unarmed ordnance was safely jettisoned. The copilot, Lieutenant (jg) Marshall E. Dickens, came down from the flight deck to be sure that all crewmen had bailed out and then climbed back up the ladder to the cockpit to tell the pilot he could now depart the aircraft. Moments later, Lieutenant (jg) Marshall was seen to jump from the rapidly descending flying boat, but tragically, his parachute streamed, and he was killed on impact with the ground.

Pilot Lieutenant Collier had come down from the flight deck but realized he was too low to parachute. The loss of an engine and the weight of his aircraft, coupled with a raging in-flight fire, prevented him from clearing the ridge into which the P5M-2 crashed at about 3:27 p.m.

An eyewitness, Bob Burrell, was situated on his property and saw the massive flying boat with its 118-foot wing span heading toward him, but he said the aircraft veered away at the last second. Burrell described seeing the doomed pilot standing at the exit door, ready to jump when the P5M-2 Marlin crashed into a boulder-strewn ridgeline and burned.

In 2015, the author interviewed two survivors who served in VP-48 aboard Bu No 135483. Richard B. Tippetts was an ensign at the time of the accident. He parachuted to safety at one thousand feet or less above a small valley, and he was third from last to bail out. Tippetts served nine years in the navy. Lawrence J. Denault, aviation electrician's mate, second class, served in the navy for eight years and was second to last in bailing out, jumping at about eight hundred feet above ground level. Denault recalled that the owner of a gas station in Descanso used his truck to pick up those who had parachuted to safety. The body of Lieutenant (jg) Dickens was respectfully covered by his parachute until authorities arrived.

When the P5M-2 Marlin survivors were interviewed by naval accident safety investigators, and later by members of the press, they were unanimous in praise of their pilot, Lieutenant (jg) John G. Collier, for his heroic struggle

to keep the flying boat in the air long enough for them to bail out. Praise was also given to the copilot, who was the last crewman to bail out, making sure that all others who could jump had preceded him.

In October 1959, John G. Collier was posthumously awarded the Distinguished Flying Cross by President of the United States Dwight D. Eisenhower. The citations honoring the memory of John G. Collier used words emblematic of his deeds on January 1, 1959: skilled, steadfast and sacrificing of his own life to ensure the safety of others. John G. Collier was twenty-five years of age at the time of his death. He was survived by his wife, a one-year-old son, his parents and one brother.

The Project Remembrance Team visited the crash site of Martin P5M-2 Marlin Bu No 135483 in early December 2014, thanks to the cooperation of a nearby property owner, Mike Clauser. What remains on site today includes parts with prefix numbers 40-, 41- and 45-, hallmarks of the P5M series aircraft. Some debris exhibits fire damage, while other subassemblies and parts appear factory fresh, as if they were just ink stamped and painted yesterday. The author placed our national flag in the main impact area to remind all in attendance of the service, sacrifice and loss of two naval officers on January 1, 1959.

Another naval aviator hailed as a hero in 1959 was Ensign Albert J. Hickman, assigned to VF-121 at NAS Miramar, where he flew the McDonnell F3H-2N Demon. On December 4, 1959, due to an engine failure, Ensign Hickman was trying to make an emergency landing at NAS Miramar. As he lost altitude over the San Diego suburb of Clairemont, he was still two miles southwest of his base. Ensign Hickman was now too low to eject as he passed a scant two hundred feet above Nathaniel Hawthorne Elementary School, where nearly seven hundred students and faculty were in attendance and witnessed the young ensign standing up in the cockpit with the canopy open. Seconds later, his aircraft plunged into a ravine, exploding into flames 250 yards from the school. A quick response by the local fire department prevented the brush fire from damaging neighborhood homes, but the black smoke rising from the crash site signaled the death of the pilot.

The body of the twenty-one-year-old ensign was found near his partly opened parachute. Whether he jumped at the last second or was catapulted out of the aircraft on impact is not known. Ensign Albert Joseph Hickman became a hero for staying with his aircraft, missing both the school and a residential neighborhood in the process. For his heroism, Ensign Hickman was posthumously awarded the Navy and Marine Medal. Later, an elementary school was named in his honor, and in 1962, the American

Legion Post in Kearny Mesa was dedicated in Hickman's honor, as was a nearby athletic field.

The wreckage of the F3H-2N flown by Ensign Hickman was mostly removed in 1959, and the site today is overgrown by a mix of native plants, including poison oak. Most residents in the neighborhood are unaware of the tragedy that almost happened there. A walking path is located just a few yards from where a navy jet fighter fell and a young ensign died while in the line of duty on December 4, 1959.

The 1960s was a time of increased military buildup, due in part to increasing Cold War tensions that climaxed during the Cuban Missile Crisis. Soon after, things settled down as our focus shifted to the growing conflict in Southeast Asia. American involvement began on a limited basis at first, but by 1965, it was becoming a full-fledged conflict called the Vietnam War. All branches of our armed forces were soon involved, requiring more operational aircraft of all types to be available not only for operations in Southeast Asia but to sustain our NATO commitments as well.

As the F9F Cougars, F3H Demons and F4D Skyrays were being retired, a new generation of supersonic fighters was joining navy and marine fighter squadrons. The Vought F8U/F-8 Crusader entered operational service in 1957 and remained in first-line operational use until 1976. Powered by one Pratt & Whitney J-57 turbojet engine that delivered up to eighteen thousand pounds of thrust while using the afterburner, the Crusader could achieve a maximum speed of over one thousand miles per hour. During the Vietnam conflict, the Crusader became an ace maker, shooting down 18 enemy aircraft. Of the more than 1,200 F-8s built, 84 were lost in combat and more than 400 were destroyed in operational accidents.

The Crusader was joined in late 1960 by the superlative two-seat McDonnell F4H/F-4 Phantom II. It was powered by two General Electric J-79 turbojet engines that enabled the Phantom II to achieve a maximum speed of over 1,400 miles per hour. The F-4 series remained in US military service until 1992, with more than 1,200 serving with the air force, navy and marine corps fighter squadrons. Crusader losses in San Diego County topped two dozen, and the Phantom II would leave its traces as well in remote areas where hikers occasionally still chance to find them.

Collisions with mountains are most often due to poor weather, pilot error, darkness or mechanical problems. Nonetheless, sometimes aircraft seem to fall out of the sky onto mountainous terrain. This was the case when an air force Boeing B-47E Stratojet crashed in the rugged mountains southeast of Warner Hot Springs.

This B-47E carried a crew of three: pilot, copilot and bombardier/navigator. All three crewmen had ejection seats, of which two fired upward and one down. Sometimes a fourth crewman was included on specialized training flights. This was the case on the evening of January 12, 1961, when Lieutenant Colonel Irwin L. Williams joined the flight crew of B-47E 52-0533 as an instructor navigator. In case of an in-flight emergency, he did not have an ejection seat and would have to bail out manually.

The B-47E departed March AFB in Riverside County on a routine navigational training mission that ended tragically only nineteen minutes into the flight when the pilot encountered a control problem. The command pilot ordered crew ejection/bailout at about eight thousand feet at an airspeed of approximately 225 miles per hour. The only fatality was Lieutenant Colonel Williams, killed during his egress on striking the side of the aircraft.

The unmanned B-47E crashed and exploded south of Hot Springs Mountain on the Los Coyotes Indian Reservation, about one mile from the nearest habitation. Following an extensive investigation, the cause of the accident was attributed to asymmetrical fuel loading in the wing tanks. This imbalance between the right and left wings is suspected to have been the primary factor in the loss of aircraft control.

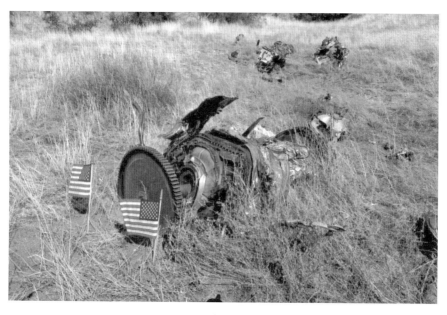

General Electric J-47 turbojet engine at the crash site of Boeing B-47E, where three air force officers survived and one died on January 12, 1961. *Photo by G.P. Macha.*

On November 17, 2012, members of the Project Remembrance Team visited the Boeing B-47E 52-0533 crash site with the cooperation of the Los Coyotes Indian tribe and their representative, P.J. Banks. What the team found was rather remarkable in that large parts of all six General Electric J-47 engines were still visible. Turbine blades were scattered across a wide area, along with landing gear and other assorted pieces—all parts of the once-proud Stratojet. Before the team departed the crash site, flags were placed for a brief memorial honoring the service and loss of United States Air Force lieutenant colonel Irwin L. Williams.

On January 17, 1961, a Grumman F9F-8T Cougar Bu No 147383 advanced trainer assigned to VA-126 at NAS Miramar crashed and exploded on a hillside east of Ramona above Hatfield Creek. Both naval officers on board were killed. The instructor pilot, Lieutenant Commander Vernon Thompson, was instructing Ensign Dennis F. Cubbison in instrument flight techniques when the accident occurred. The cause of this tragic loss is not completely understood.

Years passed, and this accident story was forgotten until 2006, when new owners occupied the land where the Cougar had crashed. When the owners started finding aircraft parts, they began asking questions. In 2009, the property owners gave the navy 350 small pieces of the F9F-8T and a dog tag belonging to Lieutenant Commander Vernon Thompson so that it could be returned to his next of kin.

In January 2015, the author visited the Hatfield Creek Winery and found the crash site well marked and remembered. Thanks to the efforts of Norman Case and S. Elaine Lyttleton, a permanent memorial marker has been placed at the crash site listing the names of the flight crew and honoring their sacrifice. Within the winery is an additional display, including crew photographs, the accident report and a few artifacts from the crash site. Thanks to Mr. Case and his family, the wine-tasting public are able to pay their respects on the hallowed ground where two aviators lost their lives while serving their nation.

Naval Auxiliary Air Station Brown Field was located southeast of San Diego, just two miles north of the Mexican border, and it was the home of Utility Squadron Seven. VU-7 used a variety of aircraft to accomplish its unique mission of towing gunnery targets, radar calibration, air-to-air gunnery, electronic counter measures, in-flight refueling, launching and directing self-propelled target drones, aerial photography and many other duties that served the requirements of the Pacific Fleet. Pilots towing gunnery banners did not want to be mistaken for the target they were

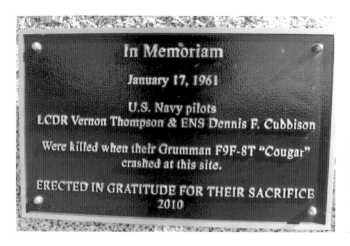

A memorial marker at the Hatfield Creek Winery honoring the loss of two naval officers on January 17, 1961. *Photo by G.P. Macha.*

towing. Therefore, the paint schemes of VU-7 aircraft were unique, using high visibility colors, such as a red tail, yellow wings and a contrasting dark blue fuselage.

Navy lieutenant (jg) Henry Marcus Harding was assigned to VU-7. His friends and family called him Hank, and he had joined the navy specifically to earn his Wings of Gold. He was married and had one child. Marc Harding remembered going to an amusement park and watching TV with his dad and always waiting for his dad to come home at night. On the night of March 27, 1961, Marc's dad did not come home. Tragically, he had flown into cloud-enshrouded 3,560-foot Otay Mountain.

In the weeks and months following the accident, the Harding family wanted to know how this tragic loss could possibly have occurred. The facts, as derived from the official investigation, stated that Lieutenant Harding was assigned to fly a North American Aviation FJ-4 Fury, Bu No 139291, from Naval Auxiliary Air Station Brown Field to Marine Corps Air Station Yuma, in Arizona. Following a routine mission near MCAS Yuma, Lieutenant Harding was to return to his assigned base.

When Lieutenant Harding returned to the San Diego area, he encountered dense clouds and radioed NAS North Island for a vector so that he might safely land in the deteriorating weather conditions. The controller gave Lieutenant Harding a compass heading that he followed as directed, but sadly, it sent him into rising terrain and to an untimely death.

When a loved one dies, families grieve, and that grief can last for years, especially for children who were old enough to know their parent. In the fall of 2005, Marc Harding contacted the author, asking for assistance in visiting his father's crash site. In October 2005, Marc flew from his Oregon home to

Above: On March 27, 1961, a navy FJ-4 Fury, assigned to VU-7, crashed near Otay Mountain, killing the pilot. *San Diego Air & Space Museum.*

Right: Navy lieutenant (jg) Henry "Hank" Marcus Harding Jr. poses with a Beechcraft T-34B following his first solo flight. *Courtesy Marc Harding.*

Orange County. The next day, the author drove him to Otay Mountain, but dense fog prevented the small Project Remembrance team from reaching the wreckage of his father's FJ-4 Fury, where Marc planned to attach a memorial plaque. Undaunted, Marc returned to Southern California in January 2006, and this time the weather cooperated, allowing the Project Remembrance Team—accompanied by *San Diego Union Tribune* writer Greg Moran and his photographer, John Gibbins—to reach the crash site.

Standing amid the remains of the Fury fighter jet, Marc spent time alone to reflect and to honor the memory of his beloved father. Then, with help from team members, Marc Harding attached a plaque to a wing section. Its yellow paint showed little fading after forty-five years of exposure to the elements. Marc thanked those who had accompanied him and then said, "When my dad died, he was doing something honorable, and I wanted to honor that." All in attendance read the words on the plaque now firmly attached to the wing. A time of silence was observed, the flags of respect were retrieved and the team began the trek back to the Otay Mountain Motorway.

A measure of closure and peace of mind had been achieved by a good son whose words imprinted on the plaque read, "To our loving son, brother, husband, father. We miss you so much. We will forever love you. We will never forget you." Marc Harding's mission was completed on a winter day with the sun shining brightly, when tears of sorrow flowed but remembrance and relief were shared.

Naval Academy graduate Lieutenant (jg) Thomas Allen Ryan was assigned to naval fighter squadron VF-121, based at NAS Miramar. His squadron flew the McDonnell F3H-2 Demon, then approaching the end of its operational service life.

On the night of May 15, 1961, Lieutenant (jg) Ryan was part of a two-aircraft practice intercept mission. As his flight was returning to Miramar, the pilots encountered a cloud layer. This was not unusual due to the proximity of the Pacific Ocean, which generates stratus clouds common in the late night and early morning hours. When the flight leader asked Lieutenant (jg) Ryan to flash his landing lights to acknowledge a radio message, the leader noted five flashes that indicated a possible failure of one of his wingman's radios. Moments later, the flight leader saw a flash as Lieutenant (jg) Ryan's Demon, Bu No 136973, crashed into mountainous terrain near the San Vincente Reservoir.

At the time of his death, Lieutenant (jg) Thomas A. Ryan was twenty-three years old. He left behind a wife and six-year-old son, Dennis Ryan.

Even though the reason for his accident was not clearly defined, the accident report cited possible pilot disorientation, engine malfunction and radio problems.

On Veterans Day 2010, Dennis Richardson led a group of interested individuals, including the author, to the crash site of Lieutenant (jg) Ryan to honor his service and sacrifice. Flags of respect were placed amid the remaining wreckage. While most of the Demon's debris had been removed, a large part of the long-silent Allison J-71 turbojet engine remained almost intact above the point of impact. After several hours of surveying the crash site, the flags were retired and the long hike back to the highway was begun.

One of the most difficult crash sites to reach in San Diego County is a Douglas A-4C Skyhawk, Bu No 150597, flown by marine lieutenant colonel Lawrence H. Brandon. Lieutenant Colonel Brandon was commander of headquarters and Maintenance Squadron 15, based at MCAS El Toro.

On June 5, 1963, Lieutenant Colonel Brandon and his wingman departed El Toro on a routine instrument proficiency training flight at 10:42 a.m. As the pair of Skyhawks reached twenty-three thousand feet, the Wright J-65 turbojet engine on Bu No 150597 began to fail. Moments later, Lieutenant Colonel Brandon's wingman radioed that he could see fuel vapor trailing the aft portion of Brandon's fuselage and that fire was present too. The fire warning light came on in Brandon's cockpit at that very moment. The estimated time from the wingman's alert to ejection was just fifteen seconds. The Douglas Escapepac System worked as intended, and Lieutenant Colonel Brandon's parachute deployed automatically around thirteen thousand feet. His descent was smooth; the landing, however, in winds gusting to thirty-five miles per hour, was anything but.

Lieutenant Colonel Brandon was dragged an estimated two hundred feet, causing him to suffer cuts, abrasions and contusions while being impaled by hundreds of cholla cactus spines. The high winds made it difficult for the marine veteran to release his parachute, something he was desperately trying to do. As he struggled, his helmet was knocked off, as were his gloves, watch and several items. Finally, the parachute hung up on a large cactus and the torment stopped, but the pain did not.

At the time of the ejection, the colonel's wingman called for emergency assistance. A coast guard helicopter arrived to effect the rescue at 11:48 a.m., guided to the accident scene by smoke from the burning wreckage of the A-4C. By 12:30 p.m., Lieutenant Colonel Brandon had arrived at NAS Miramar, from where he was taken to the hospital.

James Lievers poses with the burned but intact tail assembly of marine Douglas A-4C Skyhawk, which crashed on June 5, 1963, following successful pilot ejection. *Photo by Reed Lievers.*

Lieutenant Colonel Lawrence H. Brandon made a full recovery and returned to flying status within a month of his mishap. During Brandon's combat service in World War II, he earned the Distinguished Flying Cross and the Gold Star. In the Korean War, he earned a second Gold Star.

The search for the crash site of A-4C Bu No 150597 was accomplished by Project Remembrance Team member James Lievers. Lievers was born and raised in San Diego County, and his backcountry knowledge paid off in June 2015, when he located the Skyhawk crash site in the remote and rugged Pinyon Ridge area of the Anza Borrego State Park. A remarkable aspect of this crash site is the burned but intact tail assembly of the A-4C, which floated down to earth after it separated from the fuselage structure.

Another jet fighter that fell to earth remarkably intact following successful crew ejection was a McDonnell Douglas F-4B Phantom, Bu No 148417, assigned to VF-121 at NAS Miramar. The wreck of this unburned, broken-up, but mostly intact aircraft was visible for many years east of El Capitan Reservoir. The pilot was navy lieutenant B.H. McCart, and his radar intercept officer was marine aviator captain R.E. Kimble. The cause of the March 2, 1964 accident was an in-flight fire. Although it was once visible on Google Earth, it no longer is and may have been salvaged for aluminum value.

Good judgment and excellent piloting skills can save lives and property, as evidenced in the loss of Douglas A-4A Skyhawk Bu No 137828 on April 17, 1968.

Navy reserve lieutenant Jerry P. Shafer was assigned to a Naval Air Reserve Training Unit (NARTU) at Los Alamitos Naval Air Reserve Base in Orange County, California. When Lieutenant Shafer was not flying with the naval

reserves, he was flying for Continental Airlines as a flight engineer. He was married and had two children.

On the afternoon of April 17, 1968, Lieutenant Shafer departed NAS Los Alamitos on a training flight that included simulated ground attack passes over areas of the Anza Borrego State Park in San Diego County when he experienced engine failure. The young lieutenant immediately realized that because of his already low altitude he would need to eject. Prior to departing his Skyhawk, Lieutenant Shafer jettisoned both of his under-wing drop tanks. Seconds later, he ejected successfully.

This aerial drama unfolding over the state park was observed by a park ranger, Merle Beckman, who raced to the area where he had observed the parachutist descending. It took Ranger Beckman just fifteen minutes to locate Lieutenant Shafer and drive him to the park headquarters, from which a call was made to alert NAS Los Alamitos of the accident. The navy sent a twin-engine light transport plane to the airfield at Borrego Valley Airport to fly the unscathed lieutenant back to his home base.

In January 2009, the author visited the crash site of this A-4A flown by Lieutenant Shafer. The wreck is located on the northeast slope of 3,657-foot Sunset Mountain, and James Lievers was our guide to the crash site. Shafer's A-4A was scattered across a rock- and boulder-strewn landscape in which cholla cactus thrive.

Project Remembrance Team members with the intact horizontal stabilizer of navy reserve Douglas A-4A Skyhawk that crashed on April 17, 1968, following successful pilot ejection. *Photo by Dan Catalano.*

Several hours were spent photographing the mostly unburned remains of the diminutive Douglas Skyhawk, called "Heinemann's Hot Rod" in honor of its designer. From our mountain vantage point, we could see the line of flight where the external fuel tanks had been dropped and where Lieutenant Shafer had landed. We noted that the flight path that Lieutenant Shafer had taken avoided roadways and areas of human habitation. As we departed the remains of Bu No 137828, we took our cameras only, no aircraft parts.

Privately owned general aviation aircraft wrecks lie scattered across the hills, mountains and deserts of San Diego County as well. The majority of these losses were weather related, but midair collisions took their toll, as did losses attributed to poor pilot judgment.

On February 18, 1968, a Cessna 177 Cardinal was observed making low-level passes over the airstrip at Ocotillo Wells, where a group of dune buggy enthusiasts had gathered. On the final pass, the left wing of the Cessna struck a spectator on the ground, killing him instantly. The Cessna then pulled up, entered an accelerated stall and crashed, killing the pilot and a passenger and seriously injuring the pilot's fifteen-year-old son. The son survived the crash in part because he was sitting in the back seat with his seat belt securely fastened. The wreck of the Cessna 177 Cardinal was quickly removed, and aluminum fragments and small pieces of Plexiglas were reported at the crash site in the early 1980s—reminders of a tragic accident that claimed three lives because of an error in judgment.

One of the largest, longest serving and most versatile helicopters in military service is the Sikorsky CH-53 Sea Stallion. Flown primarily by the marines, the CH-53 has enjoyed almost fifty years of operational military service. The CH-53s flown by the marines in Southern California were based at Marine Corps Air Facility Tustin in Orange County. Since 1998, they have been assigned to MCAS Miramar.

The normal flight crew of a CH-53A is two pilots and a crew chief. Thirty-eight combat-ready marines can be accommodated, or a CH-53A can deliver heavy loads of equipment and supplies. On May 16, 1968, CH-53A Bu No 154875, assigned to HMH 462, was tasked to deliver communications equipment and a work crew to a facility on 8,716-foot Toro Peak in the Santa Rosa Mountains. The weather was clear and windy as the Sea Stallion approached the landing area when it suddenly lost lift and crashed. One crewman was killed, and fifteen others were injured. Two men sustained serious injuries, and two had critical injuries resulting from the post-impact fire.

Wreckage of Cessna 177 Cardinal at Ocotillo Well airstrip, where two men died and one boy survived with serious injuries on February 18, 1968. *G.P. Macha Collection.*

Pat J. Macha at the wreck site of USMC CH-53A that crashed on May 16, 1968, on Toro Peak. High winds were a factor in this accident. *Photo by G.P. Macha.*

The official accident report included the following factors: density altitude, wind gusts and piloting techniques. Hovering at 8,700 feet under ideal circumstances can be tricky, and when heat, wind and weight are added to the equation, it can be dangerous for all involved.

In July 2011, the Project Remembrance Team visited the crash site of the CH-53A. Flags were placed and time was spent examining the fuselage and tail section of Bu No 154875, whose paint and markings look almost factory fresh. Before departing, the names of casualties were read and the flags recovered.

Hikers, horseback riders and off-road four-wheel drivers sometimes happen upon unexpected archaeological treasures, such as pictographs, ancient campsites, fossils, meteorites, old vehicles, abandoned mines, etc. Several times each year, the author is contacted by persons who think they have found aircraft parts in remote locations. After ascertaining the approximate site location and viewing photos confirming that the material found is aerospace related, the author then searches his database to see if a match can be found. About 70 percent of the time the mystery site can be accounted for, but the other 30 percent require more information, and that may mean a site visitation.

When a popular guide to the Anza Borrego region was published, two aircraft crash sites were listed, including the Sunset Mountain A-4A. The second listing was less specific, and it turned out to be an interesting site.

In March 2015, the author led members of the Project Remembrance Team into an area near Mine Wash, south of Highway 78, where aircraft parts were reported found. The team followed the debris trail up the side of a steep mountain to where the main impact site was located. The author had no information about the crash site, but the aircraft parts that littered the accident scene had what was needed. Dozens of wreckage pieces were stamped with the letters "CV15." CV describes aircraft built by Chance Vought, and the number 15 identifies the aircraft type as the F-8 Crusader. The navy and marines both flew the F-8 jet fighter from the late 1950s into the 1970s.

Was this a fatal accident? That question was quickly answered when part of the ejection seat was found at main impact, indicating that it had not been used. The flags of respect and remembrance were immediately displayed. Who was the pilot? To what service branch was he attached, and when did this accident occur? All of these questions would be answered following an extensive newspaper search targeting the geographic area where the crash site was located.

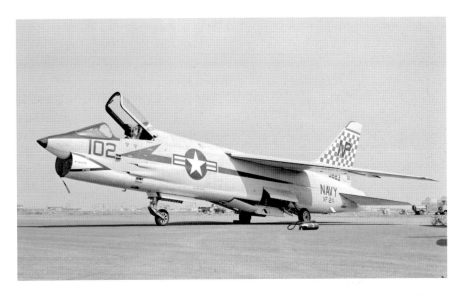

Vought F-8E Crusader, a supersonic navy jet fighter similar to that lost in a midair collision with a marine McDonnell Douglas F-4B Phantom on November 22, 1969. *San Diego Air & Space Museum.*

On November 2, 1968, navy lieutenant (jg) Michael C. Emmett departed NAS Miramar at 11:45 a.m. flying a Vought F-8J Bu No 150850. The twenty-five-year-old pilot was assigned to fighter squadron VF-124, and his mission was to practice air-to-air combat tactics that included dogfighting. While engaging another F-8 in simulated combat, Lieutenant (jg) Emmett's F-8J was seen to enter a spin, from which he attempted to recover but, sadly, did not. Why the young lieutenant did not eject is not known; perhaps he was prevented by the centrifugal forces experienced during the spin. The accident investigation team strongly recommended that all pilots transitioning to high performance fighter aircraft be given spin training and recovery techniques.

The crash site of Vought F-8J Bu No 150850 is, in the author's opinion, a memorial site where a young officer lost his life while in the service of his nation. When visiting this site, respect the integrity of site and the memory of Lieutenant (jg) Michael C. Emmett.

A midair collision happened in the skies over the Anza Borrego Desert on November 22, 1969, involved two military aircraft that were in the same area while on unrelated training missions.

Two navy Vought F-8J Crusader aircraft assigned to fighter Squadron VF-124 were practicing formation work, tactical positioning and individual aerobatic maneuvering when a marine McDonnell Douglas F-4B Phantom

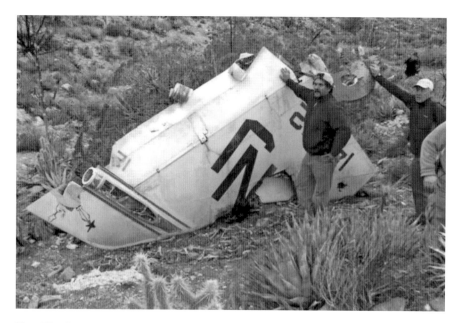

Navy Vought F-8J Crusader tail assembly on Ghost Mountain. *Photo by G.P. Macha.*

II, assigned to fighter Squadron VMFAT-101, entered the F-8J practice area. All three aircraft were operating under visual flight rules, where the *obiter dicta* is "see and be seen." The radar intercept officer (RIO) in the F-4B saw one of the F-8Js and called out a warning to his pilot, who had just completed a "clean stall" and was about to demonstrate a "dirty stall." At the same time, an F-8J pilot had called out, "Aircraft between us!" which prompted his wingman to roll and look for the F-4B, which he saw, and desperately pull back on the control stick. Tragically, it was too late, and the collision occurred, causing the F-4B pilot to be incapacitated. His RIO in the back seat initiated the ejection sequence, but only he separated from the stricken Phantom II. The F-4B pilot, Marine Captain William C. Sauer, went down with his aircraft in a flat spin. The F-4B exploded as it hit the desert floor near Highway S-2.

The F-8J pilot ejected successfully just as his aircraft disintegrated and rained parts down over a wide area on Ghost Mountain, near the fabled ruins of Yaquitepec. The pilot sustained minor injuries only, but the RIO aboard the F-4B was dragged through an area of cholla cactus by his parachute and suffered abrasions and impaling by cactus spines.

The author visited both the F-4B and F-8J crash sites with members of the Project Remembrance Team in 2008 and 2009. F-8J Bu No 149212 is

a large, widely scattered site and requires several hours to examine. The vertical stabilizer is entirely intact, complete with squadron markings and bureau number. The F-4B Bu No 150473 is a very compact site, having been a flat spin. Parts of the General Electric J-79 engines are still visible in a field of cholla cactus. It is here that flags were placed and time was taken to honor the memory of Captain William C. Sauer.

Fighter pilots must train, and that training can be dangerous, especially when the margins of speed, altitude and time combine with the unforeseen to cause accidents and sometimes the loss of life. These losses occur on our behalf to keep us safe; remember these heroes.

Aircraft accidents involving first responders are often overlooked and receive little attention. On September 4, 1970, Jean Marcel Robert was flying a fire attack mission for Hemet Valley Flying Service in Tanker 95, a WWII vintage Grumman TBM-3E registered as N9860C. Tragically, Robert was killed as he was attempting to drop a six-hundred-gallon load of fire retardant on a brush fire burning southwest of Witch Creek, about a half mile from Highway 78 near Santa Isabel. An eyewitness reported that the TBM made a steep turn over the fire and then seemed to stall and crash.

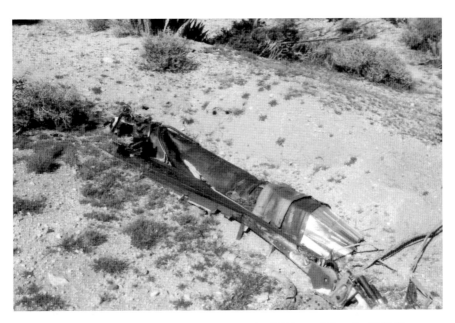

One of two General Electric J-79 engines from marine McDonnell Douglas F-4B Phantom below Ghost Mountain. The pilot was killed and the radar intercept officer ejected safely following a midair collision on November 22, 1969. *Photo by G.P. Macha.*

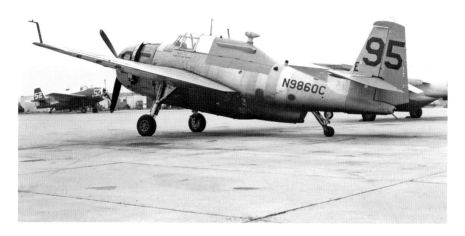

Grumman TBM-3E, Tanker E95, crashed while fighting a fire near Ramona on September 4, 1970, killing the pilot. *Photo by Milo Peltzer.*

Other firefighting aircraft dropped their retardant directly on the wreck of Tanker 95 in an effort to save the pilot's life, but to no avail.

Robert was born in Canada and had fought fires there, in California and in Chile. He had more than eight thousand flight hours, including five hundred hours in the TBM. He was married and a father of three at the time of his death. Parts of Robert's Tanker 95 are reported visible in the saddle between two unnamed three-thousand-foot hills.

Dozens of aerial firefighters have lost their lives in California since 1958. Their service and sacrifice is memorialized with a plaque in Sacramento, the state capital of California.

The accident rate for privately owned aircraft in San Diego County increased as more people took to the skies for both business and pleasure. The Volcan Mountains north of Julian have been plane catchers for many years, in part because they lie along a flight path into and out of the Greater San Diego area. Most of these losses have been weather related and include two military and nine civilian aircraft.

James W. Brown was a retired navy commander who worked as a courier pilot for Bank of America. He was assigned to deliver checks and other data to various Bank of America branches throughout Southern California. On December 21, 1970, the weather along his flight route included rain,

sleet and snow. Brown had wisely filed an IFR "instrument" flight plan. The Beechcraft Model 50 N7844C that he was flying is a dependable, twin-engine, five-seat aircraft. However, when one of the engines developed a problem in a snowstorm over the mountains of San Diego County, the consequences were dire. Thanks to good piloting skills and a measure of luck, Brown was able to crash-land west of Lake Henshaw on Angel Mountain. His emergency descent was fortunately observed by an air traffic controller, who notified the Civil Air Patrol and the San Diego County Sheriff's Department. However, the prevailing weather conditions initially prevented search flights of any kind. This did not stop members of the Angel family, residents of Angel Mountain, from looking for the missing pilot. They followed the tracks of the badly injured pilot to Highway 78 just as he was being rescued.

Brown sustained serious injuries in the crash and, fearing that he would freeze to death before being found, decided to crawl out of his wrecked aircraft to find help. It took him thirty hours to cover almost four miles before he reached Highway 78 on the evening of December 22 and flagged down a motorist. Throughout his ordeal, Brown relied on his navy survival school training, managing to drag the canvas Bank of America bank bags down to the highway with him. James W. Brown, age forty-two, had suffered shock, a broken ankle, frostbite and facial cuts, but he saved his own life while protecting the bank's property as best he could under very difficult circumstances.

Pacific Southwest Airlines (PSA) was a successful regional carrier based in San Diego. One unique aspect of the airline was that it operated its own pilot training program using the Japanese-designed and built NAMC YS-11 twin-engine turboprop light transport aircraft.

PSA often used the uncrowded skies over the Anza Borrego Desert to implement its training regimen. YS-11A N208PA was engaged in a series of in-flight training maneuvers, including induced stalls and recoveries, when one turboprop engine failed completely and the second engine suffered partial power loss. Since no parachutes were carried on these aircraft, the instructor pilot elected to make a wheels-retracted, power-off, forced landing in the desert. He accomplished this with minor damage to the aircraft and no injuries whatsoever to himself or the three other crew members.

The National Transportation Safety Board criticized PSA regarding maintenance procedures and inadequate supervision by the instructor pilot as factors in this accident. Recovering the YS-11A from the Anza Borrego Desert was complicated and costly. Today, only a few small parts remain at

On March 5, 1974, a PSA Airlines turboprop YS-11A used for crew training purposes force-landed in the Anza Borrego Desert State Park without injuring the crew of four. *G.P. Macha Collection.*

the crash site eight miles east of Borrego Springs, where a training crew and their aircraft came to grief on March 5, 1974.

Two fatal jet fighter accidents at NAS Miramar just days apart drew national attention in June 1976. Both losses involved the Grumman F-14A Tomcat two-seat all-weather fighters that had entered fleet service in 1974. The losses on June 21 and June 23 shared two things in common: both aircraft were practicing touch-and-go landings, and both flight crews had attempted to eject from their respective aircraft. Tragically, the ejections were unsuccessful.

Grumman F-14A Bu No 159838 and F-14A Bu No 159839 were assigned to VF-124, and both crashed on open space lands that are part of Miramar base property. The cause of these accidents was attributed to a combination of factors. Possible high angle of attack and darkness were cited in one loss, and angle of bank and loss of altitude were cited in the daylight loss.

The perplexing loss of five navy and marine aviators in a twin-engine jet training aircraft on April 1, 1977, remains a mystery to this day. The aircraft type involved was a North American Aviation T-39D Sabreliner, one of forty-two delivered to the navy. During its long service life (1963–89), this was the only navy D model to be involved in a fatal accident.

The mission assigned to the crew of T-39D Bu No 150545 stipulated that the students fly a cross-country navigational training flight. The flight had originated at Whiting Field–North near Pensacola, Florida, where training squadron VT-3, the Red Knights, was based. The T-39D crew continued to MCAS Yuma, Arizona, for a lunch and refueling stop. Around 2:00 p.m., the flight departed for NAS Miramar via the Anza Borrego Desert area, where the crew was to practice high-speed, low-level visual navigation techniques. The weather that fateful afternoon was partly cloudy, with strong wind gusts reported over eastern San Diego County.

At 2:48 p.m., the T-39D crashed about seven miles southeast of Julian, near the S-2 Roadway and close to the old Stage Coach Trail. All five crewmen on board were instantly killed. The crash impact and explosion echoed for miles across the Anza Borrego Desert. Smoke from the post-impact fire attracted the immediate attention of fire and law enforcement units.

The largest recognizable pieces of the T-39D were the aft-mounted engine nacelles, tail section, right outer wing and parts of the left wing. Hundreds of smaller parts littered the crash scene, and many of these fragments are still present today, marked by a small memorial adorned by an American flag.

On April 12, 2012, the author and members of the Project Remembrance Team visited the crash site of Bu No 150545 to pay respects to the five deceased crewmen. Flags were placed amid the wreckage as the names

North American Aviation T-39D, a navy trainer similar to one lost on April 7, 1977, in which five navy and marine aviators were killed near the S-2 Highway in the Blair Valley. *San Diego Air & Space Museum.*

Marine aviator Mike D. Anderson, shown here with a T-34B on his solo day at Pensacola, Florida. At the time of his death on April 7, 1977, he was serving as a USMC captain and instructor pilot on T-39D Bu No 150545. *Courtesy William Ryan Anderson Hoie.*

of the crew members were read aloud. Honored that day were pilot Mike D. Anderson, captain, USMC; copilot John M. Granzella, ensign, USN; instructor/ navigator Paul B. Durling, lieutenant, USN; student flight officer Edward B. Johnson, ensign, USN; and student flight officer Ronald C. Rigsby, ensign, USNR.

The accident report indicated that the T-39D may have been too low as it transited the training area, and the fact that turbulence was reported by other military in the area could have been a factor in the crash. The compact nature of the T-39D wreckage also suggested a possible stall spin scenario, but this has not been confirmed. What is confirmed is that five navy and marine officers lost their lives on April 1, 1977, while engaged in a routine training mission. They left behind loved ones who remember them to this day for their service and sacrifice. In August 2015, the author was contacted by the son of Captain Mike D. Anderson. He requested information that would assist him to visit his father's crash site. He was nine years old at the time of the accident, and he remembers his dad as a kind and caring man whom he will always miss.

Cessna 182A N3979D disappeared on December 27, 1977, on a flight from Boulder, Colorado, to San Diego during a period of bad weather. Extensive search and rescue missions were launched when the Cessna 182A failed to arrive in San Diego as scheduled. These search efforts paid off thanks to signals received from the Cessna's ELT (emergency locator transmitter), which was activated by the crash impact.

On December 29, 1977, the helicopter crew of a San Diego County sheriff's aviation unit spotted the wreckage of the missing Cessna near the top of rugged 3,210-foot Rock Mountain, located some twenty-three miles east of metro San Diego. It seemed unlikely that anyone could have survived the crash, but as a sheriff approached the badly damaged Cessna 182A, he heard a voice asking for help. The sole survivor of the

accident was a ten-year-old girl who had been ejected from the aircraft on impact. She had survived two days and nights of rain showers in forty-degree temperatures with a fractured jaw and other crash-related injuries. Her grandmother had also been ejected but had survived for a short time only. Her grandfather was found in the cockpit, still strapped in his seat, apparently having died on impact.

The National Transportation Safety Board report stated that the pilot had "continued VFR flight into adverse (IFR) weather conditions." For many years following the accident, the wreckage of N3979D remained undisturbed on Rock Mountain until the massive cedar fire of October 2003 ravaged the area, reducing the Cessna to melted globs of aluminum.

The worst air disaster in San Diego County and California history occurred on September 25, 1978, when a Pacific Southwest Airlines Boeing 727 N533PS and a civilian Cessna 172 N7711G collided, killing a total of 144 persons; 135 died on the airliner, 2 were killed in the Cessna 172 and 7 residents of North Park, a San Diego suburb, were also killed. The victims on the ground included 5 women and 2 boys.

The accident occurred at 9:01 a.m. in clear weather with ten miles visibility. Approach Control had advised the PSA flight crew, as they prepared to land at Lindbergh Field, that a Cessna 172 was nearby. The PSA crew did briefly see the Cessna before losing visual contact with it. The Cessna pilot and his instructor were engaged in instrument flight training and were likewise alerted by Lindbergh Approach Control about the proximity of the PSA Boeing 727, but to no avail.

The collision was captured on film by two individuals, one of whom photographed the death plunge of the stricken Boeing 727 while the other filmed the Cessna 172 as it broke up in flight after being struck from behind by the descending airliner. In the months following this aerial tragedy, the NTSB and FAA studied ways to prevent such an accident from happening again. The results included a thorough investigation and an accident report that assigned a measure of responsibility to air traffic control, the PSA pilot and the Cessna instructor pilot.

As a result of this accident, new regulations and systems were developed. TCA (Terminal Control Airspace) required all air traffic to be under FAA air traffic control. The development of TCAS (Traffic Collision Avoidance System) became mandatory for all airline and civilian executive aircraft. Private aircraft could be equipped with TIS (Traffic Information Service equipment) and a transponder that would make all aircraft visible to FAA air traffic controllers.

PSA Boeing 727 plunges to earth following a midair collision with a Cessna 172. This iconic photo captures the worst air disaster in San Diego County history, in which 144 people died in the air and on the ground. *San Diego Air & Space Museum.*

In spite of the aforementioned safety protocols and advances in technology, a midair collision occurred in Los Angeles County, California, on August 31, 1986, when a private aircraft entered Class B Airspace without permission, resulting in the loss of eighty-six lives.

The heyday of small resorts, spas and campgrounds in the interior of San Diego County prompted an increase in the number of airstrips that catered to private pilots. Some are still in use today, although several have closed along with their adjacent recreational facilities.

On Saturday afternoon, May 5, 1979, a Beechcraft Model 50 departed the Butterfield Ranch Airstrip near the S-2 Highway for a short flight to the San Diego area. On board were five close friends whose names now appear on a monument plaque in the Sawtooth Mountains about four and a half miles southwest of their departure point.

When the pilot of the Beechcraft Model 50 N16MM departed the dirt airstrip, he flew straight up Cottonwood Canyon. When he realized that

he wasn't going to clear the ridge on which Sunrise Highway is located, he apparently attempted to execute a left turn to fly back down the canyon. Sadly, the pilot was flying into a box canyon from which there was little chance of escape. The winds at the time of the crash were cited by the NTSB as gusting to seventy miles per hour.

The crash site of N16MN was visited by members of the Project Remembrance Team in December 2014. The terrain is rugged, and much of the wreckage is still visible, scattered below a memorial marker that was attached to a flat rock, above an almost vertical drop-off. The names of the crash victims are listed on the marker along with these words: "In Memory of Five Friends, We Shall Miss Them."

Marine Corps Base Camp Joseph H. Pendleton covers more than 122,000 acres in northwest San Diego County and is bordered by the Pacific Ocean and Orange and Riverside Counties. The base was established in 1942 and is one of the most important marine facilities on America's West Coast. Marine Corps Air Station Camp Pendleton is the home of Marine Air Group 39.

More than a dozen aviation accidents have happened on Camp Joseph H. Pendleton. Most of these losses occurred during simulated close air support training missions that involved both fixed and rotary wing aircraft. One incident just off the base involved a Boeing CH-46E, known as the Sea Knight. The CH-46 has been a workhorse for the marines since 1964 and is now being phased out of service. It was still in its heyday on March 2, 1988, however, when a CH-46E assigned to HMM-161 crashed on a mountain peak in the Cleveland National Forest.

The accident happened when the Sea Knight was practicing evasive combat maneuvers and collided with an abandoned forest service fire lookout tower on the summit of 3,193-foot Margarita Peak. Both the tower and the CH-46E sustained major damage. Miraculously, there was no post-impact fire, even though the fuel tanks had ruptured. The marine crew of four escaped with minor injuries.

In July 2012, the author visited the crash site and found micro debris from CH-46E Bu No 153331. The concrete foundation and some of the twisted metal structure of the lookout tower were visible also, reminders of a winter day in 1988 when good fortune smiled on four marine aviators.

Travels in San Diego County open space have always been rewarding for the author. Looking for aircraft accident sites can lead to breathtaking vistas, unexpected encounters with wildlife and some of the finest local people the author has ever met.

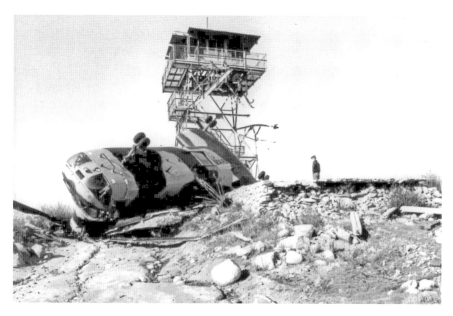

Marine CH-46E Seaknight helicopter lies upside down after colliding with fire lookout tower on Margarita Peak. All four crewmen escaped with minor injuries. *US Navy Official via Brad Ells.*

While exploring the Otay Mountain area in 1998, a concrete blockhouse was observed that overlooked the Pacific Ocean. It was built in the WWII era and has long since been abandoned. What made this building especially interesting was a dog bed with water and food bowls next to it. An inquiry with a border patrol agent led to this story. For several years, a stray dog made the blockhouse his home. The agent said that the dog was probably following migrants across the international border and that he became separated from them or was driven off.

The fact that the dog survived in a hostile environment where mountain lions and coyotes prowled and where water is scarce amazed members of the border patrol. Some border patrol agents brought food and water for this solitary animal that one of them called "the sorrowful dog of Otay Mountain." What became of the dog is not known, but the author never passes the blockhouse without looking to see if he is, by some chance, still there.

The road that passes the blockhouse has been used on several occasions by the author to visit crash sites in the Otay Mountain area east of Doghouse Junction, including the site of an executive jet that was chartered to carry members of Reba McEntire's band. The accident occurred on March 15,

1991, when a Hawker Siddeley HS-125, N831LC, struck an Otay Mountain ridge, killing all ten persons on board. McEntire was in a second chartered jet that had departed Brown Field just minutes after N831LC; happily, her aircraft cleared the high terrain without a problem.

The NTSB found that several factors contributed to the accident, including the 1:45 a.m. departure time on a moonless night and, most importantly, the miscommunication between the pilot and an FAA controller. The pilot of N831LC asked whether staying below three thousand feet would be OK as a departure altitude, and the controller said it would be fine. The pilot was referring to MSL (mean sea level), and the controller thought he meant AGL (above ground level).

Scattered wreckage of the HS-125 is still visible on the ridgeline where it crashed, marking the place where time stopped for ten people in the late winter of 1991.

We rely on the first responders for good reason: because they are there when we need them. Their job is a risky and demanding one, and sometimes we lose them as they fly to protect us. This was the case on June 21, 1995, when two firefighting aircraft were approaching the Ramona Air Tanker Base following a fire attack mission in the Anza Borrego State Park. The air tanker was an Aero Union Douglas C-54G Tanker T-19 flown by Gary Cockrell and his copilot, Lisa Netseh. The US Forest Service lead-in aircraft was a Beechcraft Baron, flown by Michael Ray "Smitty" Smith. Tragically, both aircraft collided on final approach to Ramona Airport, killing all three aviators. The crash destroyed two homes but, thankfully, without loss of life in either residence. One property owner attempted to fight the fire consuming the C-54G with a garden hose, but his heroic efforts were to no avail.

Sometimes pilots get lucky when the cruising speed of their aircraft is low enough for them to survive a crash impact, even with a mountain. This happened on December 11, 2000, to the two-man crew of a Cessna 172, N4959R, belonging to the flying club at NAS North Island. Their flight plan was straightforward: practice touch-and-go landings and takeoffs at three San Diego–area civilian airports. Both pilots were experienced and instrumented rated, but as low clouds and fog enveloped the area into which they were flying, something went wrong, and they crashed on 2,791-foot San Miguel Mountain about seven miles from the airport on which they intended to land. Both men survived, but in serious condition. The pilot was able to call 911 on his cellphone. That call brought immediate help from first responders. In this case, it was the Heartland Fire Department in El Cajon.

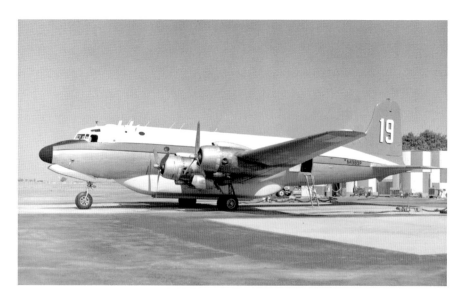

Douglas C-54G Tanker T-19 and a forest service aircraft collided near Ramona Airport following a successful fire attack mission on June 21, 1995. All three persons aboard both aircraft were killed. *Photo by Milo Peltzer.*

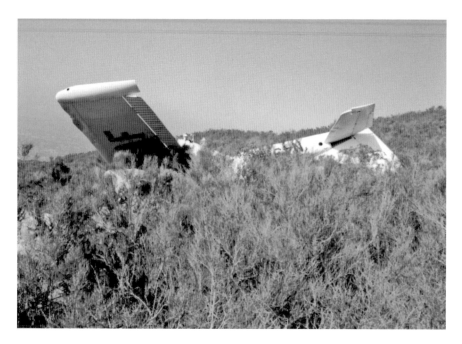

The upside-down wreck of Cessna 172H N4959R, which crashed on chaparral-covered San Miguel Mountain on December 11, 2000. Both pilots survived the accident with serious injuries. *Courtesy George Petterson.*

San Diego County has experienced more midair collisions than any other county in California. The majority of these losses have been military, and most of them occurred between 1925 and 1955. Nonetheless, even in the modern age of TCAS, FIS and advanced radar systems, midair collisions still happen. The "see and be seen" rule has not lost its importance, as evidenced by the following story.

On Sunday, August 16, 2015, two aircraft were entering the pattern to land at Brown Field Municipal Airport. The weather was clear and hot, and both aircraft had been in radio contact with the tower just before the collision occurred. The largest aircraft involved was a North American Rockwell Sabreliner, a twin-engine business jet operated by BAE Systems for defense-related work. The Sabreliner had a crew of four, all of whom were killed in the resulting crash. The sole occupant of the Cessna 172 was killed also. The NTSB has not issued a final report at the time of writing. An eyewitness stated that the collision occurred over open space lands on Otay Mesa, touching off a brush fire.

CHAPTER 4

SECRETS OF THE DEEP

More than one hundred years of civilian and military aviation in San Diego County have left their mark in San Diego Bay and the Pacific Ocean beyond. To know the exact number of undersea aircraft wrecks is a major research project in its own right. New technologies have helped to reveal the locations of dozens of historic aircraft, some of which will be discussed in this chapter. There are still many unresolved missing aircraft cases, and a conservative estimate of aircraft losses in San Diego County waters and just beyond is several hundred. The vast majority of these are military losses, associated with myriad flight regimens that include training, testing, ferrying, patrolling and search and rescue missions.

Midair collisions over water took their toll on aircraft and flight crews. One of the worst accidents involved two Consolidated PBY-2 Catalina flying boats that collided at night while on a training mission northwest of San Diego on February 22, 1938. Both aircraft were assigned to patrol Squadron VP-11. A total of eleven crewmen were killed, with three others seriously injured.

On August 29, 1940, a young marine lieutenant attempted to land his Grumman F3F-2 Bu No 0976 aboard the aircraft carrier USS *Saratoga*, but he was forced to ditch. The pilot, Robert E. Galer, survived uninjured. First Lieutenant Galer went on to earn the Distinguished Flying Cross and the Medal of Honor during WWII in the Pacific Theater of Operations.

In 1988, a navy submarine discovered Bu No 0976 in 1,800 feet of water. A recovery effort on April 15, 1991, brought the Grumman fighter plane

to the surface intact, and a complete restoration of this rare aircraft was achieved by the San Diego Air & Space Museum. F3F-2 Bu No 0976 is now displayed in the National Naval Aviation Museum at Pensacola, Florida.

During World War II, offshore training and patrol losses skyrocketed. Most of these overwater accidents involved fatalities, such as the midair collision of two Douglas SBD Dauntless dive bombers on July 18, 1942. One pilot parachuted safely into the ocean, where he was rescued by a crash boat, but the other pilot disappeared without a trace.

An army Lockheed A-29 Hudson light bomber crashed in the ocean ten miles south of Point Loma on August 13, 1942, killing the five-man crew. Only one body was found floating amid a small oil slick and debris field. This loss betokened the many dozens of army, navy and marine aircraft that were lost in the offshore waters of San Diego County, most with fatal results and many with no trace of the aircraft or crew remains recovered.

A routine training mission on September 13, 1942, led to the fatal crash of an army air force Lockheed Lightning fighter, P-38F, 41-2346, several miles northwest of La Jolla. The exact location of this aircraft is currently being sought in an ongoing effort to document military aircraft wrecks in the coastal waters of San Diego County.

One enduring mystery is that of a delivery flight from the Grumman factory in New York State to Naval Air Station San Diego. The flight of two TBF-1 Avenger torpedo bombers proceeded normally until the final leg was resumed following a refueling stop in El Centro on March 14, 1943. According to the navy accident report, neither pilot checked the weather report before continuing to San Diego, where low clouds, rain showers and squalls awaited the approaching aircraft. Once they cleared the Laguna Mountains, from that point on instrument flight rules prevailed. The only TBF-1 to land safely was that flown by navy lieutenant Mulvihill. The second ship in the flight was TBF-1 Bu No 06427, piloted by Ensign William C. Lohsen and his crewman, Aviation Machinist Mate Second Class Donald M. Keating, USNR.

Bu No 06427 was posted missing when it failed to arrive at NAS San Diego, and a search effort was initiated. However, weather limited search flights, and rough seas caused search vessels considerable difficulty. Mexican authorities were alerted about the missing aircraft, and for good reason too, as a number of United States military aircraft had crashed in remote areas of Baja California during the 1930s and early 1940s.

After two weeks of searching, the missing Avenger was presumed lost at sea, along with its crew. Next of kin were duly notified, and the war effort

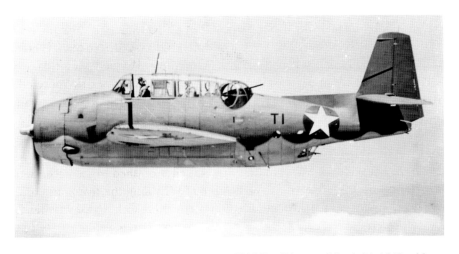

A navy Grumman TBF-1 vanished en route to NAS San Diego on March 14, 1943, with a crew of two on board. This photo depicts a similar Avenger in 1942–43 markings. *San Diego Air & Space Museum.*

continued unabated. As time passed, only family members and close friends wondered about the fate and final resting place of the missing navy airmen.

Phil Strandvold, a cousin of Donald M. Keating, contacted the author in December 1998 asking for assistance in locating the wreckage of the Bu No 06427 in the waters off San Diego. Stranvold provided news articles and postcards from his aunt about the disappearance of her son aboard the missing Grumman Avenger. Myrtle Keating had lost another son to injuries sustained in combat during WWII, and she was understandably heartbroken. Phil Strandvold's brother Ken became involved, writing letters to his senator and to the Department of the Navy in an effort to learn more about the disappearance of their cousin, all to no avail. However, in recent years some progress has been made, thanks in part to technological advances in undersea imaging and mapping of anomalies that can, in some cases, be examined by divers and remotely controlled submersibles. If aircraft wrecks are found in waters deeper than two hundred feet, the aluminum skin tends to be better preserved, and as a result, squadron markings, serial numbers and bureau numbers can be documented, revealing the identity of a specific aircraft.

During the 1990s, the author learned that several TBF and TBM Avengers had been located off the San Diego County coast, including one that the reporting diver said had a skeleton in the cockpit. Another Avenger was found off La Jolla in 230 feet of water by crews extending a sewage outfall

pipeline. The most dramatic discovery was that made by the Raytheon Corporation while testing equipment off Solano Beach, where it discovered an intact Grumman TBM Avenger at a depth of 1,750 feet.

The TBF/TBM aircraft remained operational with the navy and marines for almost fifteen years. During this period, there have been more than a dozen Avenger losses at sea off the coast of San Diego County. Some of the Grumman Avenger wrecks located in recent years are undocumented in the sense that few bureau numbers have been identified. Thanks to the efforts of Gary Fabian, Steve Lawson and others, some of these Avenger wrecks have been identified. Yet the fate of Grumman TBF-1 Bu No 06427 remains unresolved as of January 2016. Hopefully, the crash site of Ensign William C. Lohsen and AMM Second Class Donald M. Keating will be found and the wreaths of remembrance and respect will one day be placed on the blue Pacific waters over the long-missing Grumman Avenger Bu No 06427.

One WWII wreck that has been found off Torrey Pines in the La Jolla area is that of army air force Lockheed P-38G 42-13381, flown by First Lieutenant Gaston M. Hensley. On May 28, 1943, Lieutenant Hensley was flying with two other P-38s from the 330th Fighter Squadron based at NAS San Diego. These P-38s were flying low over the water when Lieutenant Gaston's P-38G was caught in the propeller vortices of the two leading aircraft, causing him to hit the ocean surface. Miraculously, he bounced back into the air and continued flying with bent propellers. However, one of his two Allison engines was failing. Realizing that he could not gain enough altitude to bail out or reach the shoreline, he elected to ditch his stricken aircraft. This he did successfully. He escaped without injury from his sinking P-38. During the Second World War, very few pilots were able to successfully ditch a P-38 and survive, and Lieutenant Hensley is a member of that elite group. The wreck of the P-38G flown by Lieutenant Hensley was discovered using side scan sonar during the search for a missing Cessna 310R that vanished on February 7, 1994.

There is another P-38 still being sought by searchers today. This aircraft, P-38F 41-2346, was seen plunging into the ocean about three miles northwest of La Jolla on September 13, 1942. The body of the pilot, Second Lieutenant Wendell F. Seppich, was never recovered, a reminder that not all missing issues are confined to war zones.

Ensign Robert F. Thomas successfully ditched his Grumman F6F-3, Bu No 66237, on January 12, 1944, twelve miles west of San Diego. No one ever expected to see that aircraft again. Ensign Thomas went on to a distinguished naval career, becoming a WWII Ace with five and a half kills.

He earned the Distinguished Flying Cross and had achieved the rank of lieutenant commander at the time of his retirement.

The intact Grumman was imaged during a scan of the ocean floor in March 1970. On October 9, 1970, it was raised from a depth of 3,180 feet by the Deep Quest submersible. Deep Quest was designed and operated by Lockheed Missile and Space Company on behalf of the navy. The recovery of Bu No 66237 was a test mission for Deep Quest that yielded a WWII artifact that now resides at the National Naval Aviation Museum in Pensacola, Florida.

Another pilot to survive a ditching, and later be decorated for valor in combat, was Marine Second Lieutenant Patrick Dugan. He was flying over the Pacific Ocean west of Camp Pendleton in the famed Corsair fighter plane when his Pratt & Whitney R-2800 engine suddenly quit. The sea state on December 1, 1943, was anything but flat, and the ensuing water landing meant trying to avoid the largest sets of incoming swells. Unfortunately, the Corsair slammed into a swell and flipped over, but Dugan managed to open the canopy, release his seat belt and swim to the surface. With his life vest inflated, he was quickly rescued by a coast guard vessel that was on station nearby.

Patrick Dugan rebounded quickly and completed his advanced training, and during WWII, he earned the Distinguished Flying Cross for heroism in the Pacific Theater of Operations.

A photo taken at NAS North Island in the early 1970s of a navy Grumman F6F Hellcat that was recovered from the ocean at a depth over three thousand feet. *G.P. Macha Collection.*

The wreck of Dugan's Corsair was located by legendary San Diego resident and diver Dave Miller in 2012. Since then, Steve Lawson and David Finnern have visited the inverted remains of the Goodyear-built Corsair FG-1 Bu No 13191 in fifty-one feet of water.

Martin PBM Mariner flying boats were a common sight during its long operational service with the navy and coast guard from WWII until the mid-1950s in the San Diego area. A key attribute of flying boats was their ability to land at sea to accomplish rescues of survivors of sinking boats, ships or ditched aircraft. However, the major limitation of open ocean landings was the sea state.

In an effort to perfect open ocean landing techniques, coast guard aircrews frequently practiced landings and takeoffs. This was the case on November 18, 1949, when a USCG PBM-5G Mariner was lost during a training session five miles southwest of Point Loma with a crew of ten on board. The copilot was practicing an open ocean landing in a challenging sea state when the Mariner stalled, causing the right wing tip float to submerge. As a result, an entire section of wing tore off. This caused the flying boat to roll on its side. Fortunately, the entire crew escaped without serious injuries.

The only parts successfully salvaged from this PBM were the two wing tip floats, which were towed to shore the day after the accident. An effort to tow the floating fuselage to shore failed when it abruptly sank. The wreckage of the flying boat was left on the ocean bottom, joining at least seven other Martin Mariners lost in operations in the San Diego area. One of those was a navy PBM-5, Bu No 59223, assigned to patrol squadron VP-73, which crashed at sea seven miles west of NAS North Island, killing all eleven crewmen on board.

In recent years, Gary Fabian began studying US Geological Survey (USGS) undersea data off Point Loma and suggested that Steve Lawson make an exploratory dive on several anomalies in that area. In 2015, Lawson located the wing section and one Wright R-2600 radial engine still in its cowling with all four propeller blades attached. This PBM-5G crash site is characterized by a flat, sandy bottom where marine growth is slowly covering most of the aircraft structure.

While Mariner's 118-foot wing span and 80-foot fuselage length is large, there is another aircraft wreck off the San Diego coast that is massive. The 230-foot span and 162-foot length of the Convair B-36D Peacemaker makes it the world's largest bomber to achieve operational status. Powered by six Pratt & Whitney R-4360 reciprocating engines and four General Electric J-47 jet engines, the B-36D had a range of 7,500 miles while cruising at a

A diver inspects the wreck of a coast guard Martin PBM-5G Mariner flying boat that crashed off Point Loma on November 18, 1949. All ten crewmen were rescued. *Courtesy Steve Lawson.*

speed of 225 miles per hour. A flight crew of fifteen airmen was required for operational missions. The gross weight of the B-36D was 357,500 pounds, making it one of the heaviest aircraft ever to fly.

Convair had two manufacturing facilities: Lindbergh Field in San Diego and Fort Worth, Texas, where the B-36 was built. The Convair plant at Lindbergh Field did the modifications that upgraded the B-36A and B models, adding the four J-47 jet engines, two under each wing. Once the modifications were completed, a Convair flight test crew would put the B-36 through a series of tests before signing the aircraft off to the air force, where it would ultimately rejoin a squadron of the Strategic Air Command.

On August 5, 1952, a Convair flight test crew of eight departed Lindbergh Field to begin a series of daylong procedural tests, which included flying a simulated bombing run over a military range in Imperial County, east of San Diego. A high-speed, low-altitude run was made over the Pacific Ocean, and an emergency landing gear extension was made at 5,000 feet. After all tests were completed, B-36D 49-2661A lined up to land back at Lindbergh Field. The final approach was made from over the Pacific Ocean at 4:30 p.m. at an altitude of 2,500 feet. Suddenly, the number five Pratt & Whitney R-4360 twenty-eight-cylinder engine caught fire and in seconds dropped off the right wing of the B-36D. Moments later, the number four engine burst

into flames, and it, too, dropped off the stricken aircraft, leaving the right wing a burning sheet of flame.

The pilot, David H. "Dave" Franks, immediately rang the bailout bell and called all crew members via the interphone to depart the burning bomber as quickly as possible. Roy Summers, the radioman, transmitted a mayday call, set the transmission key on continuous and bailed out, albeit without his "Mae West" life vest. Next to jump was second flight engineer Don Maxion, who narrowly missed hitting the main landing gear by just a few feet as he departed the stricken B-36D. Number three out was copilot Roy Adkins, followed by radar technician Bill Wilson. Moments later, engineer Ken Rodgers jumped without a life vest, followed by "Tex" Ashmore, who was injured exiting the escape hatch. Tex may have been the last to jump, and he was so low when he pulled his D-ring that he swung only twice before hitting the water.

During these frantic minutes, Dave Franks turned the burning B-36D away from San Diego and out to the open ocean in an effort to ensure that no coastal city or community would be harmed by his crashing bomber. The fate of Walter W. "Walt" Hoffman, the first flight engineer, is not clearly

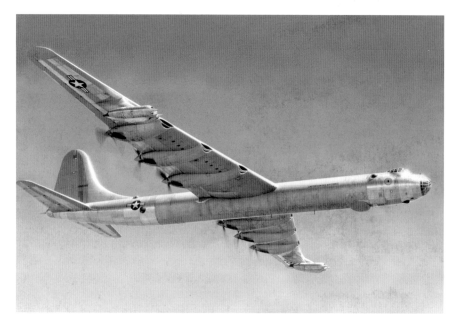

A Convair B-36D Peacemaker crashed into the Pacific Ocean west of San Diego on August 5, 1952, during a factory test flight, killing two, but eight survived thanks to the efforts of the heroic pilot. *San Diego Air & Space Museum.*

understood. Hoffman was the first crewman to see engine number four on fire and alert the pilot. While no one saw him jump, eyewitnesses reported counting seven parachutes. Most crewmen did not have enough time to put on their life vests before exiting the aircraft, and sadly, this may have been the case for Hoffman too.

Once in the water, Don Maxion got out of his parachute harness and made a floatation device by tying off the arms and legs of his flight suit. Don was rescued by a coast guard Sikorsky helicopter that, minutes later, picked up Roy Adkins. Adkins did not have a life vest, and neither did Roy Sommers, who was picked up by a fishing boat after treading water for almost thirty minutes. Sommers was transferred to a navy ship that was searching for Dave Franks and Walt Hoffman, delaying his return home until that evening. Ashmore was rescued by a navy vessel engaged in a training mission near the crash scene. Ashmore, wearing his "Mae West," had only been the water for twenty-eight minutes.

A dramatic rescue was made when a coast guard Grumman UF-1G Albatross amphibian landed on the ocean to save the life of Bill Wilson. Bill had been in the water for more than forty minutes without a life vest, and he was exhausted. A rescue swimmer from the Albatross reached him with but seconds to spare. Ken Rogers was saved when a low-flying aircraft dropped an inflated "Mae West" close enough for Ken to swim to it. A short time later, a coast guard Martin Mariner flying boat landed and picked him up.

All hope for the rescue of hero pilot Dave Franks and first flight engineer Walt Hoffman went down with the sun on May 5, 1952. In the days that followed, floating debris from the B-36D was recovered, but no trace of Dave Franks or Walt Hoffman was ever found.

The air force accident report offered three possible causes for the in-flight fire that brought down the Peacemaker: malfunction of the number five alternator, a fuel leak in the vicinity of the number five engine or the failure of the number five engine supercharger or its exhaust system. Parts of number six engine and other assorted items, including a section of bomb bay door, were salvaged for study, but they provided no additional clues as to what actually happened.

A memorial gathering of bereaved next of kin, surviving crewmen, their families and friends culminated in a wreath-laying ceremony over the crash site. Most of the surviving crew went back to flight test work, always wearing life vests, but some carried extra survival gear, including flares and flashlights. In November 1952, the B-36 modification program was completed without any additional mishaps.

The years passed, and the accident was largely forgotten until 1998, when Donald R. Maxion wrote an account of the events of August 5, 1952. His memoir sparked the interest of a *San Diego Union Tribune* staff writer, Mark Sauer, who wrote an article titled "Bail Out." Sauer's article piqued the interest of local scuba divers, who began a search for the B-36D 49-2661A. In the early years of the twenty-first century, some of them claimed to have found the remains of the gigantic aircraft in 270 feet of water, the wing and fuselage covered in coral.

Some students of undersea archaeology were skeptical of these early claims, and they set out to find the wreck of the B-36 using the latest technologies available. Spearheading this effort was Gary Fabian, founder of UB88.Org. Using publicly available USGS multi-beam data, Gary, John Walker and Captain Ray Arntz, skipper of the *Sundiver II*, made a series of side scan sonar searches west of Mission Beach. They identified a possible target in October 2008 and used a drop camera to confirm that they had found the final resting place of the B-36D.

In December 2008, the *Sundiver II* returned to San Diego with skipper Ray Arntz, the author and highly skilled technical divers John Walker and Kendall Raine. Though visibility was limited, John and Kendall were able to photo document and measure an intact fifty-six-inch tire from the main wheel undercarriage. They also found a landing gear strut, a massive section of wing structure with spars and self-sealing fuel cells. The dive team also located a section of fuselage with the remains of a plexiglas sighting blister that may have been the one used by first engineer Walt Hoffman to report the fire in the number five engine.

When the December 2008 mission was made public, feedback was received from some of the surviving next of kin, including the son of first engineer Walt Hoffman. Walt was thirty-six years old and married with a son and daughter at the time of his death. He had served as a USMC pilot, and he also flew with the Royal Air Force before joining Consolidated Vultee Aircraft Company. He made the transition to Convair, where he was widely respected by those with whom he worked. His son Frederick was twenty-two months old and his daughter was five when their father was lost in the B-36D accident.

Fred Hoffman wrote Gary Fabian a message of thanks for what the UB88.Org. team had accomplished on behalf of his sister and other next of kin. Expressing his appreciation in helping his family better understand the events of that sad day in August 1952, Fred also requested the opportunity to visit the waters above his dad's crash site.

On a brisk fall morning in October 2009, Fred Hoffman and his grandson Nathan met Captain Ray Arntz, the author and his wife, Mary Jane, for an ocean trip aboard the *Sundiver II*. After an hour's journey, the *Sundiver II* was in position over the B-36D crash site. In the thirty minutes spent above the B-36D wreckage, Fred and Nathan shared some quiet time together. As our vessel rode the northwest swell and with the engine holding our place, the flowers of love, respect and remembrance were placed on the blue waters of the Pacific. Dave Franks, the hero pilot, was remembered at this time too for his courage and sacrifice that gave others a chance to live.

As we turned east, Captain Arntz reminded all on board that the location of the B-36D crash site would not be publicly shared out of respect for both Dave Franks, who went down with his aircraft, and Walt Hoffman, who drowned nearby. With a rising sea behind us, the *Sundiver II* sped toward Mission Bay.

An underwater survey being conducted off the San Diego coast in 1992 led to the discovery of a military aircraft. The remotely operated vehicle (ROV) provided a video of the wreckage, and it was not difficult to identify it as a Grumman Avenger. In early January 2007, Gary Fabian and Ray Arntz located a target using side scan sonar that they believed to be the mystery Avenger.

On January 31, 2007, noted divers John Walker and Kendall Raine examined the wrecked Grumman, photographing many details, including the national insignia that was introduced in January 1947. The word "NAVY" on the side of the fuselage was instituted in 1950, and that further helped narrow the parameters of when the accident occurred. The breakthrough in learning the history of the Avenger wreck came when divers from San Diego Tech Diving, a dot-com company, found a bureau number on the wreckage in 2008. The number, Bu No 53439, made it possible to request an accident report from the Naval History and Heritage Command in Washington, D.C.

The crash date was October 1, 1952, and the Avenger version was TBM-3S2, assigned to Air Anti Submarine Squadron 23 at Naval Air Station North Island. The accident occurred during a night training flight when the aircraft struck the calm ocean surface at about 115 miles per hour. The pilot immediately exited the cockpit and went back along the wing to check on his radar man in the fuselage compartment. His crewman was already halfway out of his station, saying that he was unhurt. The pilot went back to the cockpit to retrieve his seat pack with an inflatable raft inside. Then he and his crewman walked to the end of the right wing and entered the water. The

Navy crewman Harold Tenny survived the October 1, 1952 ditching of a TBM-3S2 but inexplicably disappeared without a trace. *Courtesy Roger Neumister.*

pilot inflated his "Mae West" and his raft, but when he turned around, the crewman was nowhere in sight. The pilot called the crewman's name, but there was no response. The pilot then paddled around looking for the crewman and continued to call his name, to which there was still no response. After five hours in his life raft, the pilot was rescued by a passing civilian ship.

An extensive search for navy radar man Harold B. Tenny from Downey, California, concluded after several days with no result. It was assumed that he had drowned shortly after entering the water and that there was a remote possibility he might been pulled under, entangled in debris from the TBM-3S2 when it sank.

Another accident off Point Loma near the crash site of the TBM-3S2 occurred on April 23, 1953, when a navy R4D-8 transport plane was posted missing. The flight of the Douglas R4D-8 Bu No 17196 began at 4:00 p.m. when it departed NAS Alameda in Northern California with a crew of five and twenty-five passengers en route to NAF El Centro in Imperial County. Once the passengers disembarked, the R4D-8 was refueled and the flight continued on to NAS North Island. Following a brief stopover to drop off one passenger, the R4D-8 departed at 10:14 p.m. en route back to NAS Alameda. Low clouds blanketed the offshore waters, and the wind was light. Personnel at Coast Guard Light Station Point Loma reported hearing the engines of the departing R4D-8 surge for several seconds, and then the sudden end of engine sounds was followed by an impact and silence.

A surface search was initiated at 10:40 p.m., and at 12:46 a.m., an oil slick and floating debris were found. The crew of five officers and enlisted ranks on board the R4D-8 were lost in an accident that the official navy report listed as "cause unknown."

In recent years, scuba divers have shown interest in locating the wreck of the R4D-8. Diver Steve Lawson asked Gary Fabian for assistance in locating the remains of Bu No 17196. After considerable time spent and multi-beam scans made, no trace of the ill-fated R4D-8 has been found.

Independent search efforts in recent years have failed to locate a navy Douglas R4D-8 that crashed less than two miles from Point Loma with a crew of five on board. *San Diego Air & Space Museum.*

The Convair Company introduced many innovative designs during the 1950s, including one of the largest and fastest flying boats ever built. The prototype was designated XP5Y-1 because the navy initially wanted a long-range patrol bomber. The XP5Y-1 was powered by four Allison XT40-A-4 turboprop engines that developed 5,500 estimated horsepower. The wing span was 145 feet and the length was 139 feet. The XP5Y-1 weighed in at an impressive 160,000 pounds and could achieve a cruising speed of three hundred miles per hour. The aircraft was ahead of its time in many respects. The flight test program went well except for some problems with the then-revolutionary Allison turboprop engine and gearbox that drove two counter-rotating propellers.

A routine test flight on July 15, 1953, began well with a Convair flight test crew of nine on board XP5Y-1 Bu No 121455. The flight ended abruptly at 3:14 p.m. when an elevator torque tube broke, making the aircraft uncontrollable. The torque tube failure occurred at ten thousand feet, and pilot Don P. Germeraad radioed a mayday and ordered his crew to bail out as the flying boat began its dive into the ocean. All nine aircrew got out successfully, with Germeraad jumping last at about two thousand feet above the sea.

The rescue response was immediate, with coast guard and navy flying boats, amphibians and helicopters making most of the crew recoveries. A naval vessel and a private yacht picked up one man each. None of the survivors was seriously injured, and all of the crew had their life vests on, as mandated following the B-36D loss in 1952.

The XP5Y-1 project was canceled, but the basic design went into limited production as the R3Y-1 and R3Y-2 transport aircraft. A trio of nonfatal accidents, related to the Allison engines, led to the early retirement of all Tradewinds aircraft in 1958.

The loss of the XP5Y-1 happened about six miles west of Point Loma. Perhaps this crash site will be located in the future and documented by an ROV or scuba divers if the depth is not too great.

The XF2Y-1 Seadart was another unique Convair product designed to operate exclusively from the ocean's surface. The sleek twin-engine delta wing aircraft, flown by Convair test pilot Charles E. Richbourg, achieved 825 miles per hour in shallow dive, becoming the only seaplane ever to fly faster than sound.

Sometimes accidents occur in near perfect flying conditions and in front of hundreds of witnesses. This was the case on November 4, 1954, when Charles E. Richbourg was demonstrating the XF2Y-1 Seadart Bu No 135762 for navy officers and members of the press. As Richbourg was making a high-speed pass over San Diego Bay, the aircraft broke up in flight and exploded. Tragically, Richbourg was killed in the ensuing crash. He had served as a naval aviator in WWII, and he was the Convair chief test pilot for the Seadart project. The cause of the accident was listed as high-speed flight at low altitude, resulting in pilot-induced oscillation that exceeded the design limits of the aircraft. This accident is a reminder of the dangers that all test pilots face while flying new and revolutionary designs such as the Seadart.

Only four Seadarts remained following the loss of Bu No 135762; nevertheless, the flight test program continued with Billy Jack "B.J." Long as the project test pilot. When the test program ended in the fall of 1957, all of the surviving aircraft were preserved, including Bu No 135763, at the San Diego Air & Space Museum in Balboa Park.

The McDonnell Douglas F-4 Phantom II served with the United States Air Force, Navy and Marines. Phantom II production aircraft included fighter/bomber and reconnaissance aircraft variants. The marines flew the F-4B, J, N and RF-4B, a reconnaissance version.

RF-4B Bu No 153090 was assigned to Marine Composite Squadron VMCJ-3 at MCAS El Toro. On May 5, 1966, this aircraft, with a crew of

two, flew to MCAS Yuma and proceeded to an area off shore between La Jolla and Del Mar, where the pilot executed a zoom climb to forty thousand feet. Unfortunately, the RF-4B stalled and entered a spin. Unable to recover from the spin, the pilot ordered the reconnaissance systems officer (RSO) to eject. The ejection was successful, but inexplicably, his ejection seat broke into two pieces. The pilot ejected at ten thousand feet, but not without a problem, as his helmet separated during the ejection sequence, injuring his ear.

Hundreds of people in the area witnessed the flaming wreckage of the RF-4B as it was falling into the sea. By chance, a navy helicopter from Ream Field was flying nearby, and its crewmen responded immediately, rescuing both marine aviators after less than ten minutes in the water. They were flown directly to NAS Miramar, where both marines were treated for minor injuries.

The wreckage of the RF-4B was not seen again until the search for a missing chartered aircraft was initiated in the winter of 1994.

In the pre-digital age, banks chartered aircraft to accomplish the physical transfer of financial documents and checks from one institution to another in neighboring counties. These chartered flights were often undertaken at night, with each aircraft carrying hundreds of pounds of bank property in duffel bags.

On February 7, 1994, Cessna 310R N1976Y, a twin-engine six-seat aircraft owned by Pacific Air Charter, departed Montgomery Field in San Diego County at 7:15 p.m., bound for Burbank Airport in Los Angeles County. The charter pilot was a highly qualified and experienced aviatrix. She was carrying nineteen duffel bags filled with canceled checks and other bank documents. She filed an IFR Flight Plan and received a complete weather briefing prior to her departure.

The weather along the flight route included rain, heavy at times, and moderate to severe turbulence. At 7:36 p.m., as the Cessna 310R was climbing to a planned cruise altitude of six thousand feet, it suddenly began to lose altitude. Seconds later, the Cessna impacted the Pacific Ocean about two miles west of Torrey Pines. In the days following the crash, floating debris was observed near the point of impact, and some aircraft parts were recovered from the beaches between Torrey Pines and Del Mar.

At least one of the bank duffel bags was found by two fishermen, who were arrested six months after the crash while trying to cash checks at a casino in San Diego County. Prior to that, an effort was made to locate the crash site and recover bank bags thought still to be within the Cessna

310R aircraft. Champion Air Salvage, owned by noted pilot, diver and adventurer David G. Miller, was contracted to do the job. Miller, in turn, hired Deep Sea Development to assist in the operation by using its ROV. During this search, amazingly, the wreckage of the 1966 marine RF-4B Phantom II was located, as was the wreck of the army air force P-38G, successfully ditched in 1943.

Finally, the debris field associated with the Cessna 310R was found in seven hundred feet of water near the edge of the deep sea, La Jolla Canyon. To the dismay of the bank, no duffel bags were located or recovered, as they had apparently floated away. Something David Miller had suggested was possible. In December 2002, one of the bank bags was discovered by lifeguards at Blacks Beach. The bag was returned to the bank, but eight years immersed in salt water had rendered the contents unusable. Thankfully for the bank's customers, all of the lost data was eventually retrieved using computer records.

The family and friends of the Cessna 310R pilot still mourn and miss her to this day. She is one of so many fliers whose resting place is in the Pacific Ocean near San Diego, California.

GLOSSARY OF TERMS

AAF: army air field

AFB: air force base

AGL: above ground level

AMM: aviation machinist mate

BLM: Bureau of Land Management

Bu No: bureau number

CAP: Civil Air Patrol

ELT: emergency locator transmitter

Ensign (jg): ensign junior grade

FAA: Federal Aviation Administration

IFR: instrument flight rules

ILS: instrument landing system

MCAS: Marine Corps Air Station

MSL: mean sea level

NAF: naval air facility

NAP: naval aviation pilot

NAS: naval air station

NTSB: National Transportation Safety Board

RAPCON: radar approach control

RIO: radar intercept officer

ROTC: Reserve Officer Training Corps

USAAC: United States Army Air Corps

USAAF: United States Army Air Force

USAAS: United States Army Air Service

USFS: United States Forest Service

USMC: United States Marine Corps

USMCR: United States Marine Corps Reserve

USN: United States Navy

USNR: United States Navy Reserve

VFR: visual rules

VOR: very high frequency omni-directional range

WWI: World War I

WWII: World War II

BIBLIOGRAPHY

Books

Dann, Richard. *Walk Around F4F Wildcat*. TX: Squadron Signal Publications, Inc., 1995.

Ellis, Glenn Ellis. *Air Crash Investigation of General Aviation Aircraft*. WY: Capstan Publications, Inc., 1984.

Francillon, Rene J. *Lockheed Aircraft since 1913*. London: Putnam & Company Ltd., 1982.

————. *McDonnell Douglas Aircraft since 1920*. London: Putnam & Company Ltd., 1979.

Ginter, Steve. *Douglas TBD-1 Devastator*. Simi Valley, CA: Steve Ginter, 2006.

Green, William, and Gerald Pollinger. *The Aircraft of the World*. London: Macdonald & Co. Ltd., 1965.

Job, Macarthur. *Air Disaster*. Vol. 2. Weston Creek, AUS: Aerospace Publications Pty Ltd., 1996.

Larkins, William T. *U.S. Navy Aircraft 1921–1941, U.S. Marine Corps Aircraft 1914–1959*. New York: Orion Books, 1988.

Lindsay, Lowell, and Diana Lindsay. *The Anza-Borrego Desert Region*. 5th ed. Berkeley, CA: Wilderness Press, 2006.

Lloyd, Alwyn T. *Boeing's B-47 Stratojet*. North Branch, MN: Specialty Press, 2004.

Long, B.J. *Convair XF2Y-1 and YF2Y-1 Sea Dart*. Simi Valley, CA: Steve Ginter, 1992.

Macha, Gary Patric. *Aircraft Wrecks in the Mountains and Deserts of California 1908–1990*. Huntington Beach, CA: Archaeological Press, 1991.

———. *Aircraft Wrecks in the Mountains and Deserts of California 1909–1996*. San Clemente, CA: INFO NET Publishing, 1997.

Macha, G.P., and Don Jordan. *Aircraft Wrecks in the Mountains and Deserts of California 1909–2002*. Lake Forest, CA: INFO NET Publishing, 2002.

Merlin, Peter W., and Tony Moore. *X-Plane Crashes*. MN: Specialty Press, 2008.

Miller, Jay. *The X-Planes X-1 to X-45*. 3rd ed. UK: Midland Publishing, 2001.

Mireles, Anthony J. *Fatal Army Air Forces Aviation Accidents in the United States, 1941–1945*. Vol. 1, "Introduction, January 1941–June 1943." NC: McFarland & Company, Inc., 2006

———. *Fatal Army Air Forces Aviation Accidents in the United States, 1941–1945*. Vol. 2, "July 1943–July 1944." NC: McFarland & Company, Inc., 2006.

———. *Fatal Army Air Forces Aviation Accidents in the United States, 1941–1945*. Vol. 3, "August 1944–December 1945, Appendices, Indexes." NC: McFarland & Company, Inc., 2006.

Misenhimer, Ted G. *Aeroscience*. Culver City, CA: Aero Products Research, Inc., 1970.

Pearcy, Arthur. *U.S. Coast Guard Aircraft since 1916*. UK: Airlife Publishing Ltd., 1991. Repr., Annapolis, MD: Naval Institute Press, 1991.

Shad, Jerry. *Afoot and Afield in San Diego County*. Berkeley, CA: Wilderness Press, 1986.

Swanborough, Gordon, and Peter M. Bowers. *United States Military Aircraft since 1909*. Washington, D.C.: Smithsonian Institution Press, 1989. Repr., UK: Putnam Aeronautical Books, 1989.

———. *United States Navy Aircraft since 1911*. Washington, D.C.: Smithsonian Institution Press, 1989. Repr., UK: Putnam Aeronautical Books, Conway Maritime Press Ltd., 1990.

Taylor, John W.R., and Gordon Swanborough. *Civil Aircraft of the World*. New York: Charles Scribner's Sons, 1974.

Tillman, Barrett. *TBD Devastator Units of the United States Navy*. UK: Osprey Publications, 2000.

Veronico, Nicholas A. *Hidden Warbirds I*. Minneapolis, MN: Zenith Press, 2013.

Veronico, Nicholas, Ed Davies, A. Kevin Grantham, Robert A. Kropp, Enrico Massagili, Thomas Wm. McGarry and Walt Wentz. *Wreckchasing*. Castro Valley, CA: Pacific Aero Press, 1992.

Veronico, Nicholas A., Ed Davies, Donald B. McComb Jr. and Michael B. McComb. *Wreckchasing 2: Commercial Aircraft*. Castro Valley, CA: Pacific Aero Press, 1996.

Veronico, Nicholas, Michael B. McComb, Thomas Wm. McGarry and Walt Wentz. *Wreckchasing 101: A Guide to Finding Crash Sites.* Charleston, SC: Stance & Speed, 2011.

Waarde, Jan van. *US Military Aircraft Mishaps 1950–2004* Schiphol, Netherlands: Dutch Aviation Society, 2005.

INTERVIEWS

Beam, Fred. Interviews by the author, 1968–69.

Bertels, Lieutenant R.W., USNR, Ret. Interview by author, 2004.

Carson, Ralph. Interview by author, August 2008.

Case, Norman A. Interview by author, January 2015.

Gates, Elgin F. Interviews by author, 1995–2009.

Kofahl, James. Interview by author, 1984.

Peltzer, Milo. Interviews by author, 2013–15.

Petterson, George. Interviews by author, 1999–2015.

Richardson, Dennis. Interviews by author, 2008–15.

CRASH SITE VISITATIONS IN SAN DIEGO COUNTY FOR THIS PUBLICATION

December 7, 1922, DeHavilland DH-4B.

January 12, 1940, (2) Douglas TBD-1 Mid-Air.

March 12, 1942, (3) Grumman F4F-4.

March 14, 1945, Vultee BT-13A.

March 3, 1946, Douglas DC-3.

December 24, 1946, Douglas DC-3.

January 28, 1955, Grumman F9F-5.

June 3, 1955, North American Aviation SNJ-4.

December 18, 1957, Boeing TB-47B.

November 22, 1958, Lockheed TV-2.

January 1, 1959, Martin P5M-2.

December 4, 1959, McDonnell F3H-2N.

January 12, 1961, Boeing B-47E.

March 27, 1961, North American Aviation FJ-4.

May 16, 1961, McDonnell F3H-2.
June 5, 1963, Douglas A-4C.
April 7, 1968, Douglas A-4A.
May 16, 1968, Sikorsky CH-53A.
November 2, 1968, Vought F-8E.
November 22, 1969, Vought F-8J.
November 22, 1969, McDonnell F-4B.
April 1, 1977, North American Aviation T-39D.
May 5, 1979, Beechcraft Model 50.
March 2, 1988, Boeing Vertol CH-46E.
March 15, 1991, HS-125.

NEWSPAPERS

Long Beach Independent
Los Angeles Times
San Bernardino County Sun
San Diego Evening Tribune
San Diego Union Tribune

MAGAZINE ARTICLES

Bevil, Alexander D. "The Aircraft Crash Memorial on Japacha Ridge." *Journal of San Diego History* (n.d.).
Finnern, David. "Last Flight of the Corsair." *Western & Eastern Treasures* 49 (September 2015).
Holden, Dan. "The Peacemaker." *Diver Magazine*, August 2009.
Staples, Skip. "Plane Down on Palomar Mountain." *Palomar Mountain Views*, n.d.

MAPS

Harrison, Tom. San Diego Backcountry Recreation Map, Anza Borrego Desert State Park, 2009.

RESEARCH PAPERS

Endicott, Don. "Overview of Circa 1940 Naval Airplane Crash Site Artifacts (Preliminary Draft)."

CIVILIAN ACCIDENT REPORTS

Civil Aeronautics Board
National Transportation Safety Board

MILITARY ACCIDENT REPORTS

Kirtland AFB, New Mexico HQAFSCJA
Maxwell AFB, Alabama AFHRA/RSA
Naval History & Heritage Command, Washington, D.C.
Naval Safety Center, Norfolk, VA

WEBSITES

Aviation Safety Network/Flight Safety Foundation. www.flightsafety.org.
Classic Rotors Museum, Ramona, CA. www.rotors.org.
Freeman, Paul. Abandoned & Little-Known Airfields. www.airfields-freeman.com.
Fuller, Craig. Aviation Archaeological Investigation and Research (AAIR). www.aviationarchaeology.com. Resource for accident reports and photographs.
Google Earth. earth.google.com.
Macha, G.P. Aircraft Wrecks in the Mountains and Deserts of the American West. www.aircraftwrecks.com.
Patrol Squadron 48. www.vp48.org.
Planes of Fame Air Museum, Chino, CA. www.planesoffame.org.
San Diego Air and Space Museum, Balboa Park, San Diego, CA. www.sandiegoairandspace.org.

USS *Midway* Museum, San Diego, CA. www.midway.org.
Western Museum of Flight, Zamperini Field, Torrance, CA. www.wmof.
 com/display.html.

Motion Picture Classics Filmed in and around San Diego County

Devil Dogs of the Air, 1935
Dive Bomber, 1941
Flying Fleet, 1929
The Flying Marine, 1929
Hell Divers, 1932
Top Gun, 1986

Videos

Braverman Productions. *Broken Wings*. 2001.
Macha, G. Pat. *Wreck Finding "Lost but Not Forgotten."* 1995.

INDEX

Y

ABOUT THE AUTHOR

Photo by Heather Maureen Armes.

G. Pat Macha was born in Santa Monica, California; he is a graduate of Long Beach State College with a BA in history and a minor in geography and an MA from Azusa Pacific University. He taught at Hawthorne High School for thirty-five years and is married and the father of two, with five grandchildren. He has authored six books on aircraft accidents in California and is a well-received speaker on aviation safety and accident histories. Pat has been documenting crash sites throughout California in remote locations for fifty-two years, and he has hiked to or flown over more than fifty crash sites in San Diego County. Since 1996, along with the Project Remembrance Team, he has assisted next of kin in visiting crash sites and placing memorials where legal to do so. To learn more about his work, visit www.aircraftwrecks.com.